IMAGES
of America

GEORGETOWN

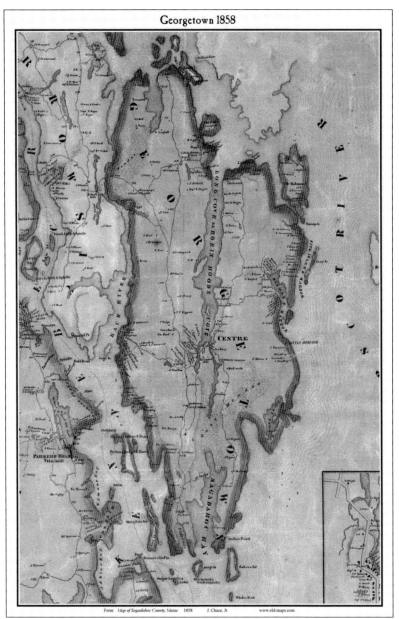

Georgetown 1858

From *Map of Sagadahoc County, Maine* 1858 J. Chace, Jr. www.old-maps.com

This map image of Georgetown was derived from an 1858 J. Chase Jr. Publishing map of Sagadahoc County, Maine, published in Philadelphia, Pennsylvania, and Portland, Maine. In 2006, King Philip Publishing made a digital scan of an original map and created this focused image of Georgetown. (King Philip Publishing.)

ON THE COVER: Shown here boarding passengers at the Five Islands Wharf, the *Wiwurna* was one of the best-known steamships to service the Bath-to-Boothbay route in the history of the Eastern Steamship Company. Built at Bath in 1884 at the William Rogers Shipyard, she ran for 41 years without mishap and was broken up for scrap in 1926 in Portland. Her captains were Irving Pierce, Ross Dickson, Gilman Lowe, Thomas Brewer, and Frank Rowe. (Gene Reynolds.)

IMAGES
of America

GEORGETOWN

Gene Reynolds

ARCADIA
PUBLISHING

Copyright © 2014 by Gene Reynolds
ISBN 978-1-4671-2150-7

Published by Arcadia Publishing
Charleston, South Carolina

Printed in the United States of America

Library of Congress Control Number: 2013949732

For all general information, please contact Arcadia Publishing:
Telephone 843-853-2070
Fax 843-853-0044
E-mail sales@arcadiapublishing.com
For customer service and orders:
Toll-Free 1-888-313-2665

Visit us on the Internet at www.arcadiapublishing.com

To the other two members of the "Three Old Men"—Hal Bonner and
Jack Swift, good men; and for my wife, Claire, "I Miss You, Hon"

CONTENTS

ACKNOWLEDGMENTS

It is a great pleasure to have the opportunity to share photographs and postcards from my personal collection with a wider audience. It is particularly gratifying since my family has such deep roots in the community.

I want to thank the board of directors and officers of the Georgetown Historical Society (GHS) for encouraging me to undertake this project. More specifically, I need to acknowledge the invaluable assistance of Jeanne Bailey McGowan, Rich Start, and Howard R. Whitcomb, without whom this book would not have come to fruition. Numerous others helped at various stages, including the following family members: niece Carrie Reed, son-in-law Dennis Russell, daughter Darcy Emerson, and grandsons Corey and Evan Reynolds. In addition, the following individuals provided assistance on a variety of tasks: Elaine Hersom, Diane Morin, Mike Stevens, and Peter Stevens. This book's introduction draws significantly from the GHS research collection, in particular the work of Carolyn F. "Billie" Todd, writing under the auspices of the historical society.

The following friends provided photographs from their personal collections: Peter Bacon, Barbara and Paul Barabe, Noreen Blaiklock, Clayton Heald, Virginia Hopcroft and Susan Bradstreet, Denise Moore Reynolds, Rich Start, David Trafton, and Elaine Todd Trench. The following organizations have photographs in this collection: the Georgetown Community Center, the Lachaise Foundation, the Philadelphia Museum of Art, and the Maine State Archives. Finally, the image of the 1605 Samuel de Champlain map of Georgetown and Phippsburg at the mouth of the Kennebec was provided courtesy of the Maine Historical Society's Maine Memory Network.

My personal collection has been augmented significantly by images from the Georgetown Historical Society. For that, I am most grateful. The following abbreviations are used to acknowledge sources of multiple photographs used in this book: Eugene A. Reynolds (GR); Georgetown Historical Society (GHS); Maine Maritime Museum (MMM); and Will Todd Collection, of Georgetown Historical Society (WT/GHS). In addition, photographs of the Golding's Company feldspar mine are from "Feldspar Quarrying in Georgetown, Maine," the bachelor's of science thesis of Matthew C. Burnham and Shawn D. Harrison, Worcester Polytechnic Institute, class of 1988, at the Georgetown Historical Society and are abbreviated as follows: MCB&SDH/GHS. All other "courtesy" attributions are acknowledged separately along with the individual photographs.

I have specified that all of my proceeds and royalties should benefit the Georgetown Historical Society.

In conclusion, Caitrin Cunningham and Rebekah Collinsworth of Arcadia Publishing were most understanding and provided valuable assistance throughout the project.

INTRODUCTION

Georgetown is an island and a town, situated between two great rivers, the mighty Kennebec River and the peaceful Sheepscot River. In fact, thanks to the unique work of Mother Nature, the glaciers, and the Good Lord, the shores of Georgetown are touched by not only those two large rivers but also the Atlantic Ocean and four smaller rivers—the Sasanoa, Back, Little Sheepscot, and Little. In addition, the waters of the two branches of Robinhood Cove caress the internal shore of Georgetown for more miles than all but the first two rivers and nearly split the island in two. Over the centuries, much has changed, but not in terms of the affection this island's inhabitants—some who were born here and others who choose to be here—have for this community they call home.

Hundreds of years ago, Georgetown Island (called Roscohegan by the Native Americans) was a place to hunt and fish for the Abenaki Confederacy led by Chief Mowhatawoemit, the sachem whom colonists later gave the name Robert Hood or Robin Hood. At one time, Georgetown was believed to have been only a summer location for Native Americans, but a more recent analysis of local shell middens seems to point out that they chose it for year-round habitation. Small shell middens have been found in two of the island's villages, Five Islands and Georgetown Center. Although there were many bloody fights with Indian warriors from the north and west, Chief Robin Hood and his tribe remained friendly and peaceful with the Georgetown settlers, and the chief eventually became a very active real estate broker.

Adventurers came from Europe to take advantage of the area's abundant natural resources. The first to come were the fishermen who, looking for better harvesting grounds, passed the message on to other seamen more interested in exploring the vast inner lands. Diggings on several islands around Georgetown have found traces of human settlements for cleaning and salting fish, perhaps dating back to the 1500s. Ships from French, English, Spanish, Italian, and Portuguese explorers made voyages into this area, including Samuel de Champlain (1605) and George Weymouth (1605), who sailed into the Sheepscot and Kennebec Rivers. Prominent on the east bank of the Kennebec was the island of Roscohegan, later Parker's Island and now what is known as Georgetown. The Champlain map in the first chapter, dated 1605, clearly identifies the southern tips of what are now Phippsburg and Georgetown.

In 1616, Capt. John Webber, with first mate and brother-in-law John Parker, established a trading post with the Indians, probably on Squirrel Point in the neighboring town of Arrowsic. By 1630, Parker had bought 100 acres of land from Robin Hood and built a house on Squirrel Point. In 1648 or 1649, he purchased Roscohegan from the Abenaki chief and built a home on the lower end of that island, living there with his wife, Mary. After his death, the land passed down to Parker's wife and children, and they lived there for many years until they were driven off during a conflict with the Indians.

By 1650, Thomas Webber had settled on the northern end of Parker's Island and married Mary Parker, daughter of John and Mary Parker. The family had 300 acres of farmland on Webber Point

and a farm where they raised sheep on Webber Island. There is still to this day a corduroy and rock road out to the island, visible at low tide, positioned just east of the Webber cemetery.

In 1716, residents petitioned to form a town named Georgetown-on-Arrowsic, to be centered on the island now known as the town of Arrowsic. In his book *Islands of the Mid-Maine Coast: Pemaquid Point to the Kennebec River* (1994), Charles McLane reminds readers "that while the records describe meetings that took place initially on Arrowsic Island, the business of the township by the 1730s covered events not only on Arrowsic and Parker's Island and in Nequasset [Woolwich] but on the west side of the Kennebec as well [Phippsburg], where settlements had been absorbed" into the new town. Thus it would be until parcels broke away, beginning with Woolwich in 1759, Bath and West Bath in 1781, Phippsburg in 1814, and ending with Arrowsic in 1841. West Bath would later break away from Bath. The separation of Maine from Massachusetts via statehood in 1820 and the creation of Sagadahoc County, the 16th and last, out of Lincoln County in 1854, gave further definition to this southern mid-coast island.

In 1753, early in the history of Georgetown-on-Arrowsic, a group of Boston businessmen, the proprietors of the Kennebec Purchase, engaged surveyor Jonas Jones to divide Parker's Island into 40 tracts, which he did on a map dated 1759. These tracts stretched from shore to shore. He drew Robinhood Cove as the starting point of all his measurements. Like the skeleton of a fish, all lines started on the cove and went off in angles away from the backbone of the fish. Thus, no lines were run directly east and west. Lots on the west side of the cove ran to the Back and Kennebec Rivers, and lots on the east side ran from the cove to the Sheepscot River. (Copies of this map by Jonas Jones, who was also a lawyer, can be purchased in area historical societies.) These subdivisions provided settlers with access to waterways as well as inland wood lots and farmland.

In 1774, Thomas Stevens and his colleague Arad Powers bought 206 acres at Five Islands from Ephraim Brown, and in 1791, Stevens acquired Powers's share. The Stevens family members, and later their Rowe relatives, were leaders in the development of Five Islands. In 1759, Peter Heal owned 200 acres on Robinhood Cove, Robert Pore (later Powers) owned 400 acres, and Seth Tarr and Timothy McCarty jointly owned 550 acres. Later, Powers bought another large tract of land just south of his first. A very old, small cemetery has been found on land located behind the old Higgins farm, near the shore. As this was the second parcel purchased by Powers, it might be his burial spot instead of on what was Pore's (now Birch) Island.

Jeremiah Beal, born in Georgetown in 1773, is buried on Beal Island. Most likely, he had a farm there. David Oliver, who married a granddaughter of John and Mary Parker, lived on Stage Island from 1677 to 1679 during the Indian raids. The Olivers, along with other local families, took refuge in Massachusetts, but their sons David Jr. and Thomas Oliver bought land at Bay Point, opposite Long Island. In 1753, John and Joanna (Pettigrew) Spinney settled on Long Island. A later Spinney subdivided the island and sold small lots for summer homes. Thomas Donnell was the first settler of Donnell (now known as MacMahan) Island, having built a house there in 1761. When the Donnell daughters married two MacMahan brothers, the name of the island was changed. Prior to 1771, a Marr family settled on Marr Island. In 1871, Malden Island, just off Five Islands, was bought by a group of families from Massachusetts and Topsham, Maine.

Although early Georgetown settlements developed around access to water, it was the island's topography and geography that encouraged the clustering of residents in mostly independent villages with names such as Bay Point, Five Islands, Georgetown Center, Marrtown, Riggsville/Robinhood, and West Georgetown. Most had their own general stores, wharves and landings, schools, and post offices as local hubs of activity, and while many of those entities are gone, there remains a village identity for many of Georgetown's residents.

Up through the latter part of the 19th century, fishing, shipbuilding, tidal mills, ice harvesting, quarrying, and raising livestock were the community's major enterprises. Commercial fishing still remained the principal industry of the island, occurring both near to shore and offshore to the Grand Banks, where the waters were rich with hake, haddock, cod, and mackerel.

Until the mid-1800s, Five Islanders shopped in Riggsville (Robinhood), where the Riggs family had essentially cornered the market in curing fish, outfitting ships, and selling from their general

store. Between 1780 and 1790, Ebenezer Rowe of Gloucester, Massachusetts, purchased land at Five Islands, and around 1850, fish-drying stages were constructed there, purportedly with start-up help from Benjamin Riggs. Joseph Grover Rowe established a general store and space for barrels of salted fish. Initially the store was probably a ships store, with supplies for local fishermen and coastal vessels. Around 1890, a general store was built, and the business carried on right at the Five Islands wharf until the 1980s.

In 1877, Hiram "Hite" G. Rowe petitioned the selectmen of Georgetown to grant a license to extend the wharf 70 feet into the tidewaters at Five Islands and added a waiting room for passengers on the Bath-to-Boothbay steamship run and a fish market. Salt fish continued to be stored on the first floor, and on the second floor, women worked canning blueberries in late summer. Oilskins, jackets, sou'westers, aprons, and gloves also were made on the second floor. By the 1880s, Rowe was an agent for the Eastern Steamship Company, whose freight and passenger vessels made regular daily stops at Five Islands. Other stops on the Bath-to-Boothbay route were upper and lower Westport Island, Riggsville, and MacMahan Island. Because of a lack of water at low tide, Georgetown Center could not be serviced. The steamboats had an incredible record over many years for moving people around quickly and without any fatal accidents. Many of the steamships had melodious names of Native American origin, such as *Nahanada, Sasanoa, Sebenoa, Samoset, Salacia,* and *Wiwurna,* to name a few.

From earliest times, the island's waters were a great local source for herring. Native Americans used weirs, and later arrivals would likely have built weirs on old Indian sites. Weirs were on the Kennebec River, at the mouth of Back River off West Georgetown, and at the north end of Robinhood Cove. In the early 1900s, the Powers brothers, Levi Wilmot, and Ambrose Burnside owned several Riggsville herring weirs and operated a successful herring trade for many years, packing them into barrels and shipping to Boston, New York, and other markets. Commercial ventures expanded into mills producing shingles, lumber, and flour, and at least one carding mill to prepare wool from local sheep, at Georgetown Center, run by the Traftons. As early as the 1700s, the Oliver and Trafton families had a lumber mill on the eastern branch of the cove and, later, a second mill on the west branch.

In early times, Georgetown's king's pines were harvested here, and soon, local carpenters turned to shipbuilding. Shipyards sprang up along the Kennebec River and around the entire island. There were three major shipyards—Trafton and Berry at Georgetown Center and Riggs at Robinhood. According to William A. Baker's *A Maritime History of Bath, Maine and the Kennebec River Region* (1973), there were over 300 ships built in Georgetown during the 1800s. General Berry built 15 ships at Georgetown Center in 15 years, from 1841 to 1856. During the peak years of his shipyard, Berry employed over 100 workers, built and operated a general store, and even constructed a boardinghouse for his employees.

Haying was a significant aspect of agriculture throughout the 19th century, usually practiced by farmers who combined it with upland farming. Frances "Babe" (Williams) Gunnell, born in 1900, had vivid memories of her family farming the marshes, as described in her book *A Nice Life Back Then: Georgetown 1900–1920* (2011). Several farmers from the northern end of the island owned acres of marshland at Indian Point, on the Little River. The Heald (originally Heal) and Reynolds families were two that would make the haying task a several-day "vacation" in late summer, packing lots of food, ice, and tents. The entire family would travel by horses and wagons, going downriver "for a picnic." They came back home with several tons of hay and a week of sun and beach.

By the early 1800s, the village of Riggsville came into its own as a commercial center, much to the credit of the Riggs family. Benjamin Riggs and Ruth Pearl of Edgecomb had married, bought land in North Georgetown (later Riggsville), and built a log cabin, possibly on the site of the present Robinhood Marine Center. Next, they built a small grocery store, just a few hundred yards below that site. That old store was the North Georgetown Post Office until James Riggs moved it to a location on the ledge as you enter the current marina. All the old post office mailboxes are still in place in what is now a private cottage. In 1820, they expanded the business with a much

larger building for the store and a wharf to service ships. After Benjamin's death in 1846, their son Moses took over managing the store and the ships hardware business. The 1820 store is now the home of Spartan Marine Hardware.

In the late 19th century, Georgetown, as well as much of the Maine coast, was rediscovered when steamships brought rusticators from large cities to small local landings. Also, with the building of new and better bridges, the need for boardinghouses, hotels, and better lodging brought new business with the arrival of summer folk. In the early 1900s, upon the death of his father, an 11-year-old boy from Harmon's Harbor named Walter Reid went to work as a deckhand on a sailing ship. He advanced to work in stores and later became a very successful salesman. He quickly succeeded in various business ventures and served as the director of the Eastern Steamship Company for Charles W. Morse of Bath and later as chairman of the board of the Mack Truck Company. Back home at Harmon's Harbor, he built the Seguinland Hotel, a large wharf for steamships, and several homes and purchased a significant amount of land in Georgetown. Reid's land purchases enabled his donation in 1946 of 776 acres to establish Reid State Park for the people of Maine. The park includes two great beaches and acres of marshes and other wildlife habitat, providing a wonderful destination for visitors, a boost to the local economy, and an overall great benefit to the town and the state of Maine. Fortunately, the Seguinland Hotel escaped the fiery fate of many old wooden buildings and today is the Grey Havens Inn. Reid's former home is the noted Mooring Bed and Breakfast.

At that time, island living required a complex piecing together of a variety of jobs and a commitment to making do. For rusticators, seasonal living would have been impossible without the knowledge and skills of the island's year-round residents. Providing goods and services to summer folk became an important source of income. Poet Louise Guiney and her friend Fred Holland Day, a Boston photographer and publisher, arrived in the 1890s. Day soon invited fellow photographer Clarence H. White to visit. The White family purchased an old farm from Reid and then established the Seguinland School of Photography, which ran summers from 1910 to 1915. White brought in artists such as Gertrude Kasebier and Max Weber to serve as faculty at the school. Sculptor Gaston Lachaise and his wife, Isabel, arrived in the 1920s, purchasing a home on the corner of Route 127 and Indian Point Road, and through them, William and Marguerite Zorach came to live here. Artists Marsden Hartley, Paul Strand, and John Marin came to visit the Lachaises and create art.

Since 1841, the town of Georgetown has been comprised of one large island, the fourth-largest in the state of Maine, with perhaps 34 smaller islands ringing its shores. It is connected to the mainland via two bridges crossing the Sasanoa and Back Rivers. Georgetown's population has fluctuated widely since the late 19th century, especially during hard times when residents emigrated for better opportunities elsewhere. The 1930 census lists a population of 361, and the island averaged about 500 residents for many years. The 2010 census reports 1,042 year-round residents, a number roughly equivalent to that of 1880. With Georgetown's 300th birthday coming in two short years, the island is still home to many descendants of that initial pioneer purchaser, John Parker. The Parker DNA is alive and well on this island. Georgetown will likely remain much like it has been for a long time to come: a small close-knit coastal community that annually welcomes its more numerous summer residents in a celebration of island life.

On the following pages, you will find a collection of archival images picturing residents at work, building a community, or relaxing and simply enjoying just being alive and looking forward to more of the same. Photography by both amateurs and professionals has been a large part of this island for over 100 years. You are invited take this photographic journey through the development of our island community. Please enjoy.

One

GEORGETOWN, AN ISLAND

Unlike many of the communities in Maine that were established by settlers migrating north from the Massachusetts Bay Colony, Georgetown was first approached from the sea. Samuel de Champlain, in his 1605 exploring of the coast of Maine, took the time to sketch the mouth of the Kennebec River, including the southern tips of what are now Georgetown and Phippsburg. Champlain was not alone in his interest in this part of the coastline, as many fishing expeditions from the Old World came to this area seeking the fruits of the sea that were here in abundance.

It was not long until these seafaring people came ashore to become more engaged with this new land. These were solitary people who carved out subsistence lives. However, as more people migrated into surrounding communities, commerce had an important hand in bringing the people of a broader area together to trade goods. The growth of trade became the impetus to get from one locale to another.

To accomplish this, crude ferries were built to convey a single horse and wagon at a time from one shore to another. To expedite travel, the ferries soon gave way to rustic and often fragile bridges. Along the banks of the rivers leading to the sea, larger ships were built to carry goods to distant ports. Navigation required safe travel, and lighthouses were built to guide ships in and out of the growing local ports. Increased trade brought greater interaction among the previously isolated settlements. It was not until 1927, with the completion of the Carlton Bridge across the Kennebec River between Bath and Woolwich, that Georgetown's connection to daily life in mid-coast Maine was secured.

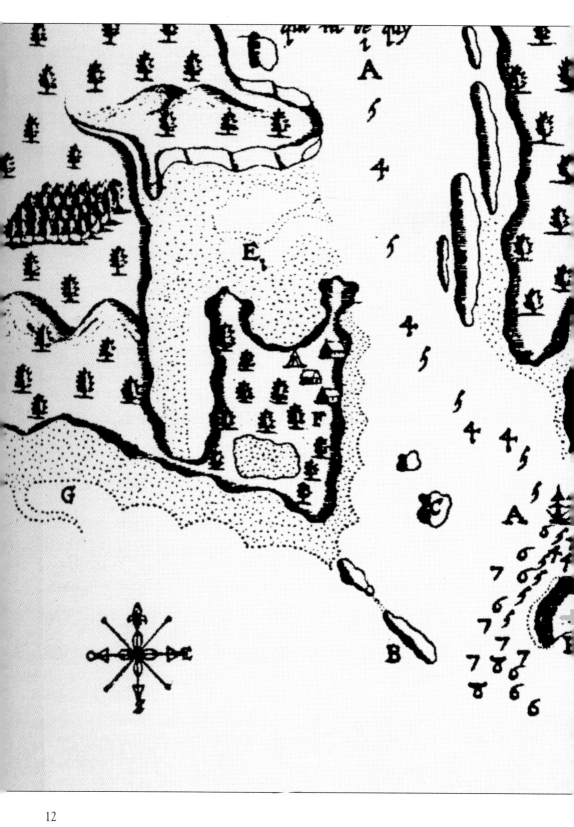

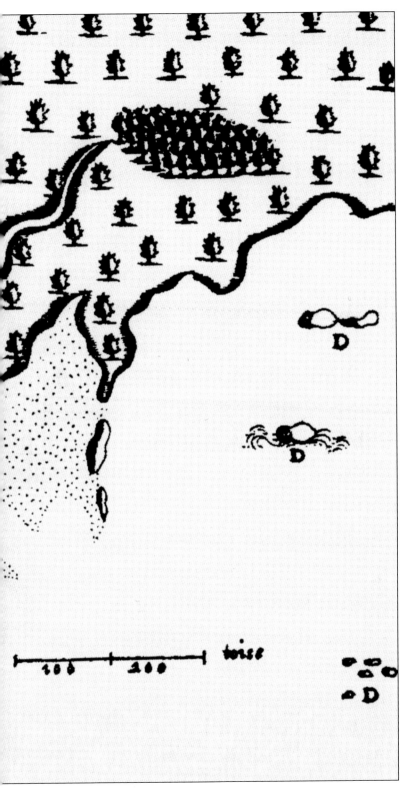

The town of Georgetown, which was incorporated in 1716 and situated on the eastern shore of the Kennebec River, has witnessed its share of the early exploration and settlement of the New England coast. In 1605, Samuel de Champlain mapped the mouth of the Kennebec River, including his anchorage at Stage Island just off the southern tip of Georgetown. Champlain also chronicled a journey he took from that anchorage up the Back River between what is now Georgetown and the neighbor island, Arrowsic. In 1716, Georgetown, or Georgetown-on-Arrowsic, was the name given to a large area surrounding this island including today's Woolwich, Phippsburg, Arrowsic, Bath, and West Bath. By 1841, each of these communities had incorporated, leaving Parker's Island in sole possession of the name Georgetown. (Maine Historical Society's Maine Memory Network.)

On the Kennebec River, off of Fort Popham in Phippsburg and Bay Point in Georgetown, a three-masted schooner, apparently fully loaded with her cargo, is sailing out to sea. In the foreground on Bay Point are several handsome cottages with a great view. (GHS.)

In this 1909 image, a magnificent ship is sailing down the Kennebec from Bath. It is one of the rare six-masters, built at Percy and Small, now the Maine Maritime Museum site. The last to be built was the *Wyoming*, the biggest wooden ship to sail commercially. She went missing, with all hands, in 1924 off Cape Cod while hauling coal from Virginia to New Brunswick. In 2013, a giant architectural model was erected at her birthplace in Bath. (GHS.)

Images of America-Georgetown
Errata Sheet

The following are the requested caption changes in the *Images of America – Georgetown* book authored by Gene Reynolds. The changes are in RED.

Page 53, top image – This date at the very end of this caption is not correct. It should be: 1971.

Page 54, bottom image – The entire caption should read as follows: "At the extreme left is Carrie Baker, daughter of John Riggs, outside her grandfather James Rigg's woodshed in the 1880s. William and Marguerite Zorach acquired this Riggsville house in 1923 and it remains in the family to this day."

Page 55, top image – The first three lines of the caption are correct. The last line should read, "The Moses Riggs house, far right, still stands, although now on the outcropping across the cove, known as 'the Knubble.'"

Page 73, top image - The entire caption is wrong. It should read, "At the end of a typical day of fishing in the 1890s in Georgetown, three men are cleaning several large codfish. The man in the middle is Joseph Stevens (Jody) of Five Islands; the other two fishermen are unidentified. (Virginia Hopcroft and Susan Bradstreet.)

Page 79, bottom image – The first five lines of the caption are correct. The last line of the caption should delete the 1851 date. That line would now read: "This image is from a painting by W.F. Marr."

Page 116, bottom image – The correct last name for Uncle Keith is MacGillivary, not Reynolds.

Page 117, top image – There are two errors in this caption. The entire caption should read: "This view of Reid State Park's Mile Beach clearly shows why it is popular with beach and nature lovers. It is hard to imagine that during World War II American and Allied air forces used it for target practice. Look down the sands from Todd's Point where the targets floated and try to visualize planes roaring out of the western sky, firing machine guns and dropping practice bombs."

November 11, 2015

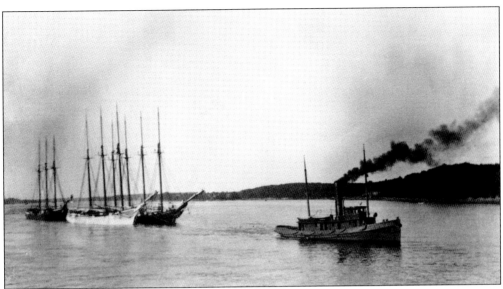

The famous tug *Seguin*, built in Bath in 1884, worked for 80 years on the Kennebec and Penobscot Rivers. Here, she is coming to the mouth of the Kennebec with three schooners in tow. Soon, sails will be unfurled, and the schooners, which are lightly loaded, will set off on their own into the Atlantic. The shore of Georgetown is in the background. (GHS.)

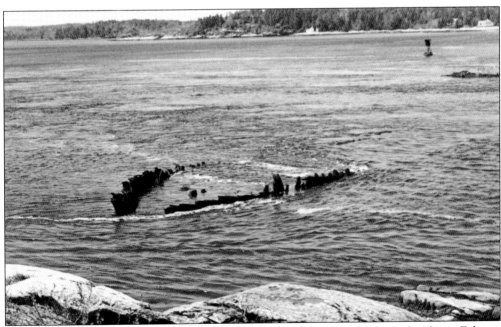

Off Georgetown's Long Island, near the mouth of the Kennebec River, is the sunken barge *Ephrata*, picked clean of her coal cargo many years ago. While she was heading for the Penobscot in a three-barge tow with the tug *Carlisle*, a bad storm forced her into the Kennebec River. Two barges, cut-down schooners named the *Eagle Hill* and *Langhorne*, beached on Parker Head Flats in the town of Phippsburg and were saved. The *Ephrata* sank, but the crew was saved. (GR.)

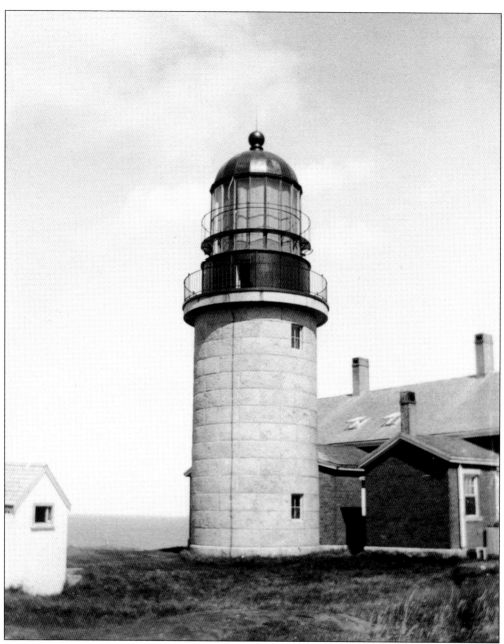

Commissioned by George Washington in 1795 and in the National Register of Historic Places, Seguin Island Light Station stands 186 feet above sea level and nearly two and a half miles out to sea. It is Maine's second-oldest commissioned lighthouse. The original wooden tower was replaced in 1819 with a stone tower and remained in commission until it was destroyed by severe weather. The current cut-granite tower was constructed in 1857. Here, a close-up shows the tower and Fresnel lens. A boat ride to this 60-acre island for a summertime visit is highly recommended. At least two modern ferries give rides to Seguin. (WT/GHS.)

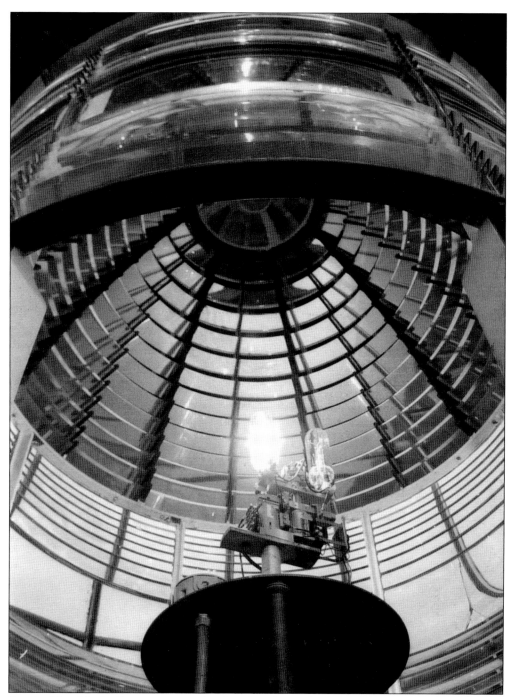

Seguin Island Light Station was outfitted with a first-order Fresnel lens in 1857, and in 1985, it was automated. The massive lens (nine feet in height and six feet in diameter) is a fixed white beam that, on a clear night, is visible for 20 nautical miles. Thanks to the hardworking volunteers of the Friends of Seguin Island Light Station (FOSILS), the lens remains on-site and is now the only Fresnel lens still in operation north of Virginia as a prominent aid to navigation. (FOSILS/GHS.)

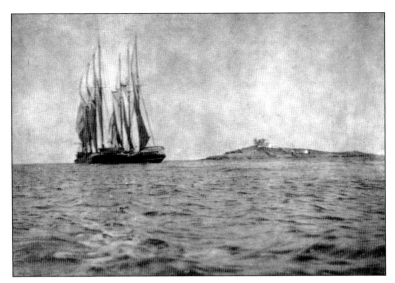

Here, a tug appears to be casting off after having hauled two four-masted schooners out from the mouth of the Kennebec River in the 1890s. Seguin Island can be seen to the southwest. The schooners, having just unfurled their sails, are catching a breeze after unhooking from the tug. (GHS.)

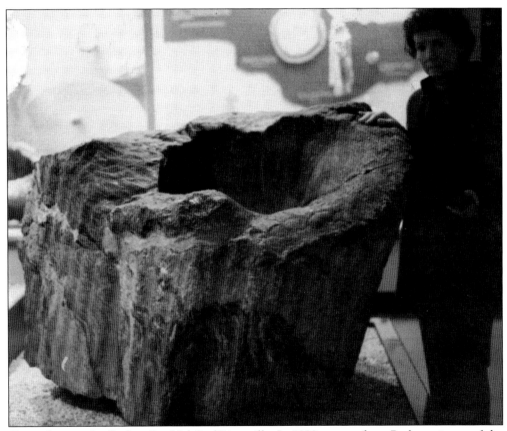

Shown here is the "Indian Pot Hole" of Riggsville. In 1898, a crew from Bath cut it out of the ledge, loaded it on a barge, took it to Bath, and reloaded it on a train to Washington, DC. Claire Reynolds is shown standing beside the rock at the Smithsonian Institution in 1985, displayed among the moon rocks. The Native Americans did not drill it; the glaciers did. (GR.)

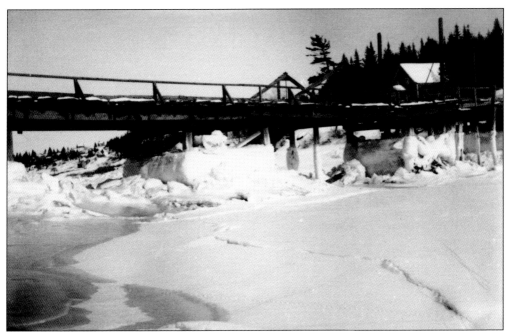

This c. 1900 image shows the structural damage to the Georgetown Center west bridge from the giant blocks of ice below. Note under the left center of the bridge is a view up Harrington Hill. On the right are the old town hall and two posts with Trafton cables that might have been a means of raising a bridge section for boat passage to and from the sawmill. (WT/GHS.)

Here is the east bridge at Georgetown Center as it was when it crossed the east branch of Robinhood Cove in the early 1900s. Several of the buildings are part of the General Berry shipyard. George Horne, a Berry descendant, says this was a drawbridge that, with a lot of effort and permits from the selectmen, would allow passage to the Berry lumber mill. (WT/GHS.)

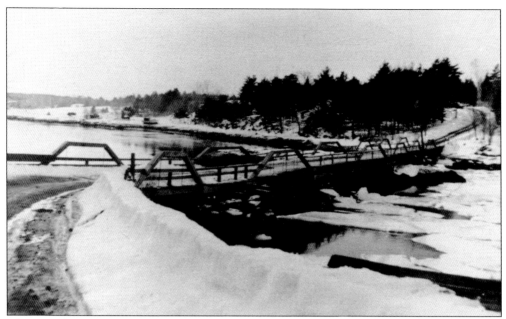

This view looking from Georgetown toward Arrowsic is in an undated image of a bridge that connected the two islands until the so-called Singing Bridge replaced it in 1932–1933. The Singing Bridge itself was replaced in 2009, when the State of Maine built a steel-frame bridge, which serves the islands well but carries no tune. (GR.)

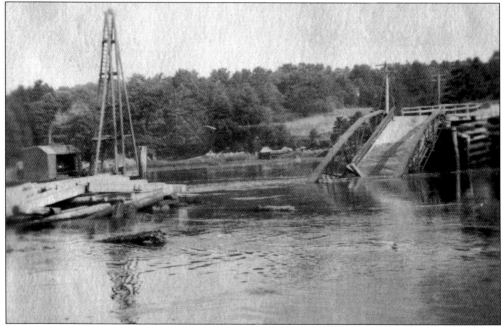

On the morning of August 1, 1919, local newspapers announced that "the Woolwich-Arrowsic Bridge had gone down." Luckily, an inspection by officials the day before had warned the public that a great calamity was about to occur. All traffic was shut down that afternoon, for fear the main span near the Woolwich side might collapse like a row of dominoes that would kick over other foundation piers and fall into the Sasanoa River. Sure enough, it happened. (Noreen Blaiklock.)

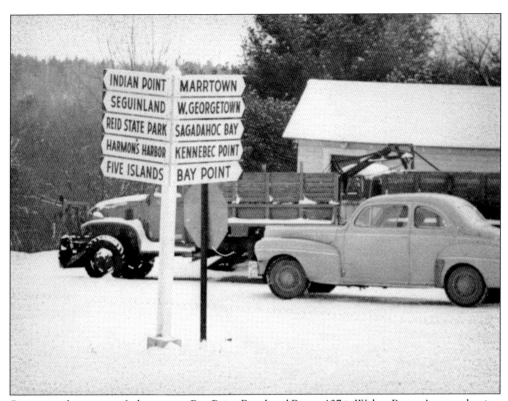

Sitting on the corner of what is now Bay Point Road and Route 127 is Walter Powers's snowplowing equipment parking lot in the early 1950s. With several World War II four-by-four trucks in his fleet, Powers plowed many miles of road and sanded four hills for $1,000 per year. Today, every inch of Georgetown's many miles of town roads must be plowed and sanded. (GHS.)

This early-1900s image shows a young couple from Massachusetts, probably here to visit an island family—and likely giving their hosts a fun ride. That open front, with no dashboard or windshield, must have been torture. (GHS.)

21

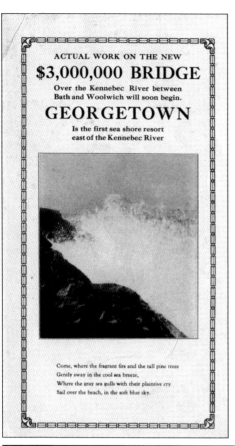

ACTUAL WORK ON THE NEW
$3,000,000 BRIDGE
Over the Kennebec River between
Bath and Woolwich will soon begin.

GEORGETOWN
Is the first sea shore resort
east of the Kennebec River

Come, where the fragrant firs and the tall pine trees
Gently sway in the cool sea breeze,
Where the gray sea gulls with their plaintive cry
Sail over the beach, in the soft blue sky.

The Georgetown selectmen published this brochure about 1925 in an attempt to entice people to the town. They hoped to capitalize on the construction of a bridge across the Kennebec River between Bath and Woolwich. In 1925, the Maine legislature appropriated $3 million and state senator Frank W. Carlton led passage of the bill. The bridge was completed in 1927 and named in honor of the good senator. (GR.)

At the October 30, 2009, opening ceremony for the new Georgetown-Arrowsic Bridge, both towns had most of their 90-year-old-and-older citizens present to cut the commemorative ribbon. Reed and Reed builders, good neighbors from Woolwich, did a great job replacing the 75-year-old Singing Bridge. Towns on both ends of the bridge are very pleased and relieved. (GR.)

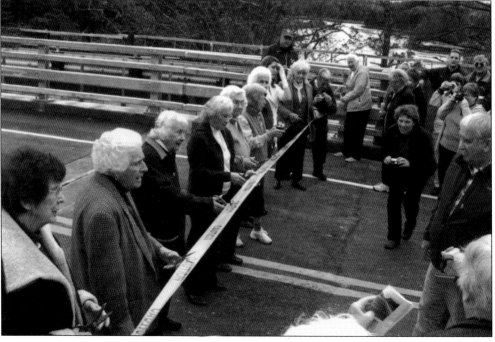

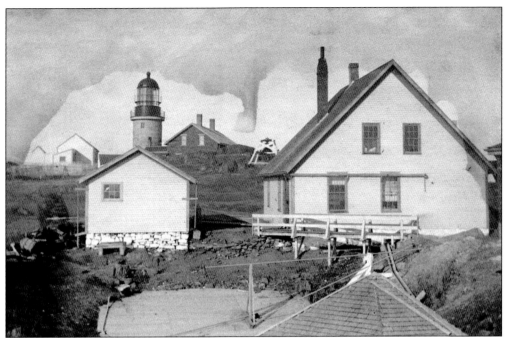

Seguin Island Light Station is one of two lighthouses in Georgetown, the other being Perkins Island Light. At times on Seguin, there were two keepers and their families tending the lighthouse. The lower buildings in the picture were torn down some years ago. Summer volunteers now staff the site, and the list to get the nonpaying positions can be quite long. (GHS.)

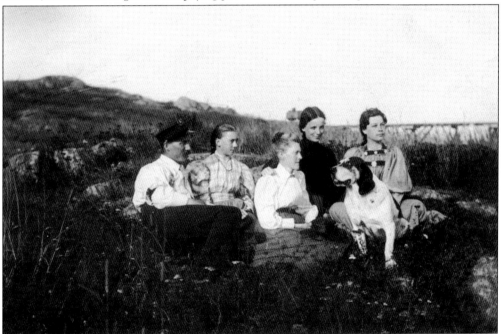

Looking out to the sea while on an outing at the Seguin Island light are the keeper and his family, from left to right, Capt. Herbert Spinney, Grace Spinney, Berthia Spinney, and Amber Young. The lady on the far right and the dog are unidentified. (GHS.)

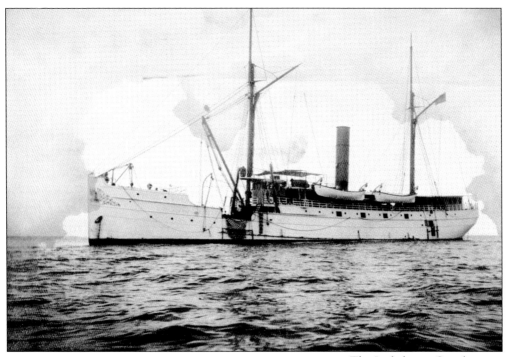

The Lighthouse Supply Ship *Ilex,* out of Portland, has arrived to service the Fresnel light, generators, and outbuildings. The ship covered most of the North Atlantic coast for many years. (GHS.)

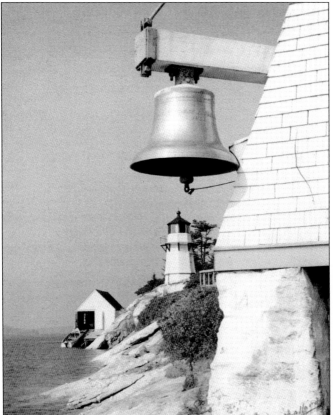

Georgetown claims two lighthouses, Seguin and the lesser-known but beautiful Perkins Island Light. Perkins Island is on the starboard side of the Kennebec River, as one comes upriver. The recently refurbished bell was donated to the town years ago and is on display in front of the Georgetown Central School. Recent efforts hold promise for extensive repairs on the keeper's house. (GR.)

Two

BUILDING A COMMUNITY

As Georgetown matured, six distinct communities developed. From north to south and west to east they are Robinhood (Riggsville), Georgetown Center, West Georgetown/Marrtown, Bay Point/Kennebec Point, Indian Point, and Seguinland/Five Islands. Robinhood was known as both a fishing and trading community and is now the home of one of the larger marine centers along the Maine coast.

Georgetown Center is where all roads from the other villages come together. The first buildings of town government were constructed there. Before the turn of the 20th century, it was known for its shipbuilding and tidal mills. West Georgetown and Marrtown, although distinctly different communities, are grouped because they share direct access to the Kennebec River on the west side of the island. Bay Point and Kennebec Point were relatively small communities until the influx of "people from away" discovered these two sun-drenched peninsulas extending out into the Atlantic Ocean at the mouth of the Kennebec River.

Indian Point had several small farms in Georgetown's earliest days. Aside from its sizable summer community, it is also known for an abundance of clams. The eastern settlements of Georgetown are grouped together as Five Islands/Seguinland. Five Islands is known primarily as the village with the most active lobster boat fleet. Seguinland is known for Reid State Park, donated to the State of Maine by Walter Reid. As the island matured, schools began to develop in most villages. Post offices also took their places, usually in conjunction with a general store. With the passage of time and the advent of the automobile, the island communities began to consolidate. A fierce forest fire in 1934 was responsible for creating an island-wide fire department. Also, a single central school replaced all the one-room schoolhouses. Despite the lessening of the importance of the separate villages, Georgetown retains its strong feelings toward local governance and its fiercely independent spirit.

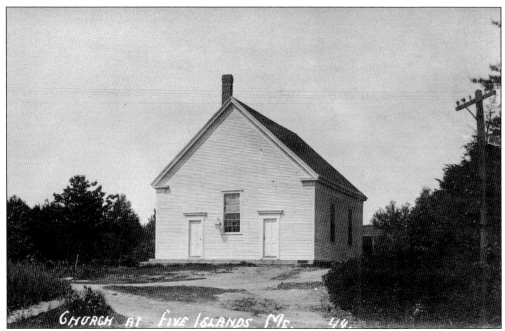

This c. 1900 image shows a structure that originally sat on the hill just west of the Robinhood turn on Route 127. Led by Methodist and Congregational ministers until being replaced by new churches in Robinhood and Arrowsic, the church was taken apart and sold to Moses Riggs. A Harmon's Harbor women's group purchased it, had it moved to its present location, reassembled, and enlarged. It became the Five Islands Second Baptist Church. (GR.)

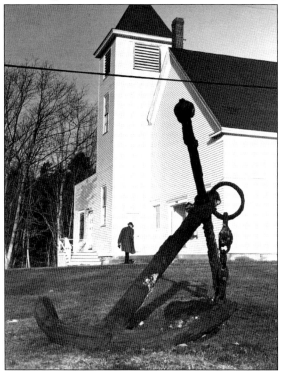

This c. 1960 picture shows Deacon Percy MacGillivary entering the Second Baptist Church early on a fall Sunday morning to turn up the thermostat and do other preparations before services. MacGillivary lived just across the road. The large anchor seen in the foreground was hauled up from the Sheepscot River by fisherman Steve Thibodeau, trucked to Campbell Square, and set on the Herbert Campbell Memorial lot. (GR.)

Airman Herbert "Herbie" Campbell was one of the heroes of the Second World War. Leaving his job at the Bath Iron Works in Bath, Maine, at age 18, he volunteered for the Army Air Corps. At 19, First Sergeant Campbell flew as a waist gunner in a B-17. He completed several successful missions, and on his 13th mission his plane was shot down over Avord, France. The crew parachuted to safety, but several men were subsequently captured by the Germans. Campbell and another gunner landed near a German airfield, but escaped and were found by a group of Free French. For several months, Campbell fought alongside them. On July 3, 1944, while planning an action against the Germans, the group was betrayed and Campbell was shot and killed while providing cover for the group's escape. He was buried in a field in France. Later, his mother went to France and brought his body back to the United States. It now lies in the small Five Islands cemetery across from the Second Baptist Church. The square in front of the cemetery has been named Campbell Square. After the war, France and the United States awarded Campbell several medals posthumously. (Denise Moore Reynolds.)

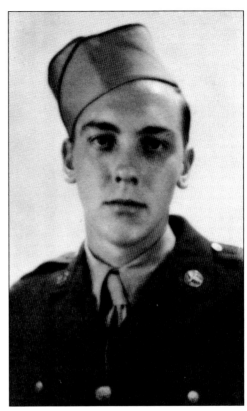

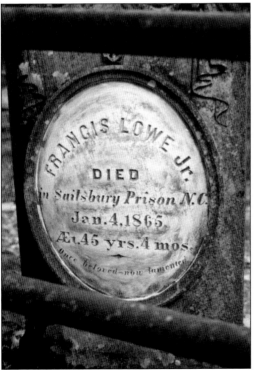

Capt. Francis Lowe Jr. sailed his vessel south during the Civil War and, against Union orders, went up a rebel-controlled river and was captured. He later died in Salisbury Prison, North Carolina. After the war, his brother went down and exhumed his body, bringing it home to Five Islands. He is buried in the family cemetery near their home. (Note the misspelling on his stone.) (GR.)

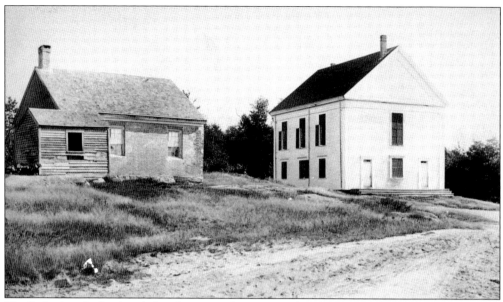

The Robinhood school and church, as seen from across the Webber Road entrance in the 1920s, are two of that village's most honored buildings. The school was sold to George Powers and family, who made it a home. The church faded away, and despite efforts by local families to have it restored, it sat vacant for many years. Eventually, it was sold and was operated as a fine-dining restaurant for a number of years. (GR.)

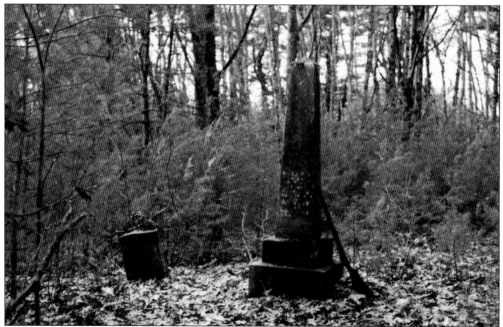

The Shea family placed this Civil War monument on Flying Point in Robinhood for their son Samuel, who was killed at Gettysburg. The famous letter to his mother that he dictated to a buddy as he lay dying is now at Bowdoin College. Three Georgetown boys died in that battle. The obelisk also honors another son, Marquis, who drowned off of England. Recently, the Russell family cleaned up the cemetery and located almost a hundred graves. (GR.)

When the First Baptist Church of Georgetown Center was built around 1829, it was farther back in the northwest corner of land provided by Jotham Trafton. In 1883, it was moved to its present location so a vestry could be built underneath. The belfry was added in 1906, and the Memorial Bell was dedicated in 1915. In 2012, the building was deeded to the town and renamed First Church. (GR.)

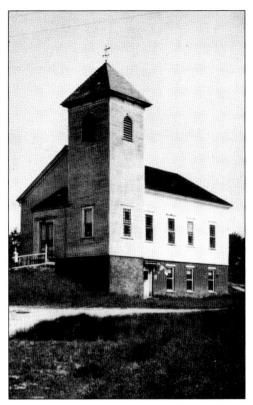

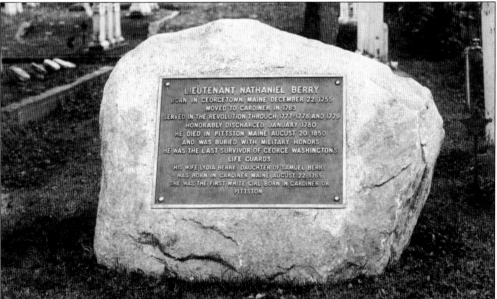

A large boulder with a bronze plaque honors Lt. Nathaniel Berry, born in what was then Georgetown (now West Bath) in December 1755. He served in the Revolutionary War from 1776 to 1780. Berry died in 1850 in Pittston, Maine, and was buried with full military honors in Maple Grove cemetery in Randolph, Maine. He was the last survivor of George Washington's Life Guards, who served as personal guards for the general. (GHS.)

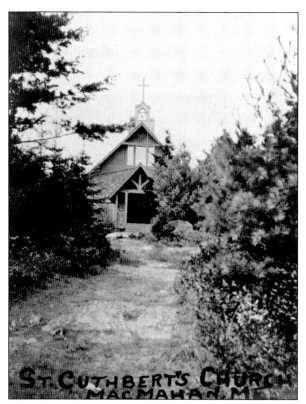

Out on MacMahan Island stands St. Cuthbert's Chapel, an Episcopalian sanctuary consecrated in 1902. According to George S. Pine in his brief history of the island, *MacMahan, Cherishing the Atlantic*, there had "always been a religious atmosphere on the Island fostered by St. Cuthbert's Chapel, never oppressive but keeping within bounds of many social activities." (GR.)

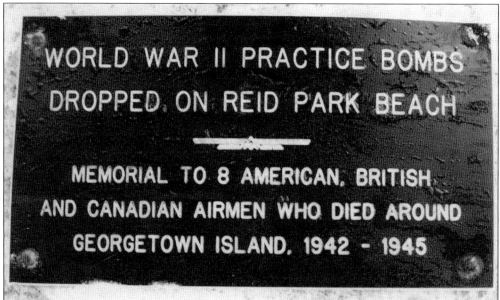

In Robinhood stands a monument to the eight World War II Air Force men who died in plane crashes around Georgetown Island while dropping practice bombs at targets just off what is now Reid State Park. The airmen would leave Brunswick Naval Air Station and fly straight down Robinhood Cove, right over the Center Grammar School (now the Richards Library), firing machine guns and dropping bombs. (GR.)

Commissioned in 1820 by Gen. Joseph Berry, the old stone South School on Bay Point Road, with a small shed attached, was built by three Irish immigrants hired to do the work. They used local stones and lumber for the construction, building it like the stone houses of Ireland. It served as the Georgetown Historical Society's home for some 37 years until the society moved into its new building. (GHS.)

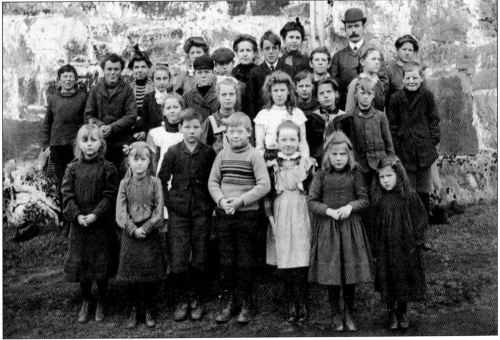

In 1905, the South School had a large student enrollment of boys and girls. Here they are with their teacher Norman Trafton. The students were from Bay Point families with names such as Oliver, Mains, Hinckley, Spinney, Harford, Marr, and Smith. The building was rented to the Cunningham family for many years before it was the home of the Georgetown Historical Society. (GHS.)

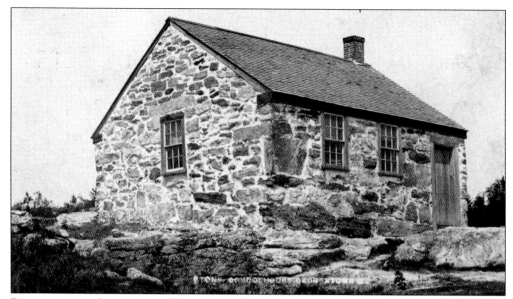

Because it is on the way to Reid State Park, the old stone Woods School is seen more frequently by travelers than the one on Bay Point. Now owned by the State of Maine, it has weathered the years well without much attention. Two of its well-known former students were Capt. Stinson Davis, a veteran seaman, and Walter Reid, a successful businessman. (GHS.)

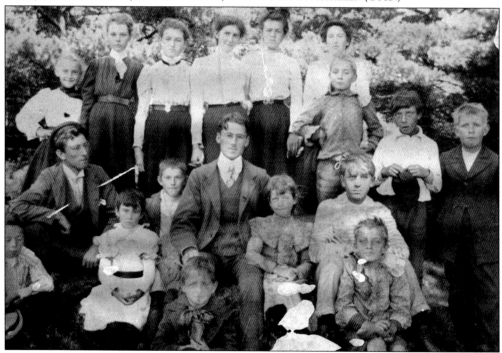

Here are Riggsville School's students and teacher around 1899. They are, from left to right, (sitting) Forest Legard, Ralph Legard, Belle Heald, Frank Heald, ? White, Oscar Williams (teacher), ? White, Charles McMahan, and Wesley Jewett; (standing) Addie Mains, Geneva Jewett, Jessie Eaton, Stella Colby, Edna Beal, Flora Campbell, Stanley Jewett, Horace McMahan, and Harold Jewett. The brick structure is now a private home. (GHS.)

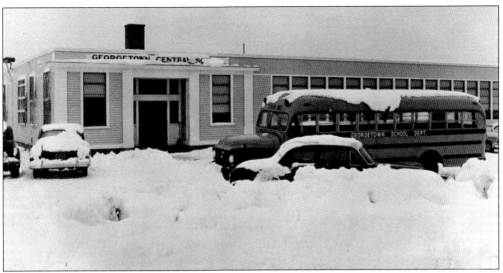

The Georgetown Central School sits among the snowdrifts with a tired older-model bus parked out front, around 1955. Percy MacGillivary was the driver then and had to do repairs on the bus almost every evening after delivering the students. Since then, the school has had several additions, the enrollment has increased, and first-class students are being produced by a capable, experienced group of caring, innovative teachers and staff. (GR.)

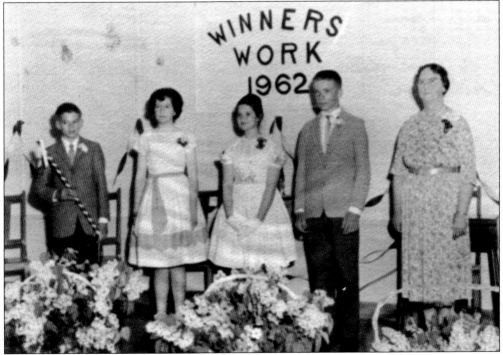

The present Georgetown Central School was built after World War II, when there were three schools in town. Georgetown was one of the first Maine towns to get state funding for a new school, from which the first class graduated in 1948. This 1962 class had three students graduating; shown here are, from left to right, Dana Cochrane, seventh-grade marshal; Edith Moore; Betsy Savage; and Andrew MacGillivary, with teacher Edith Marr. (GR.)

33

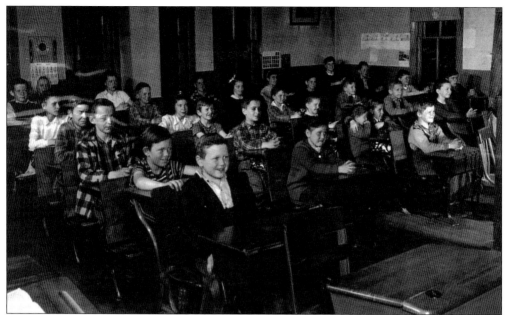

A 1947 group photograph of a Five Islands School (now the Five Islands Fire Station) classroom shows students from families whose names are still familiar in Georgetown, like Pinkham, Stevens, Clark, Hanna, Carr, Moore, MacMahan, Cunningham, Gray, Campbell, and MacGillivary. Not long after the date of this photograph, the school closed, sending its students to the new central school. (GR.)

On the right in this vintage photograph is the Old Union Hall; it was built for workers at General Berry's shipyard. It was also used as the town hall until the mid-1940s, when the selectmen moved their offices to the Georgetown Central School. For a brief period of time, local youngsters used this facility to play indoor basketball. (GHS.)

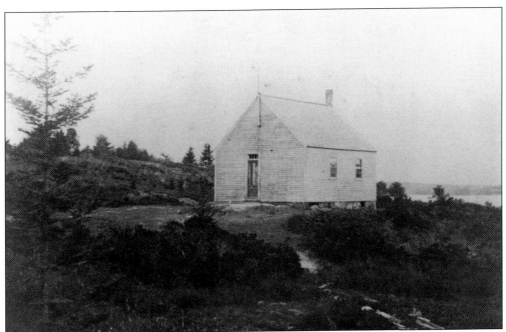

Here is the old Back River School in West Georgetown, where it stood on a slight knoll and had a view of the Kennebec and Back Rivers. Frances "Babe" Gunnell, her brothers, and the Hinckley family children were among the students. After it closed, the building was moved and became a garage for a house in Georgetown Center. (GR.)

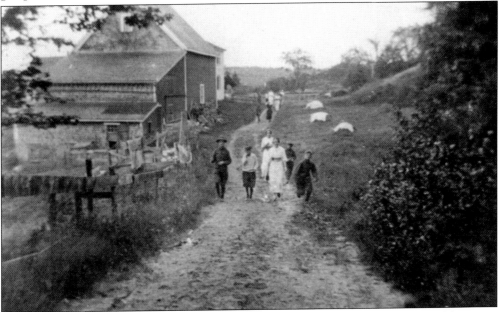

Coming home from the Free Meetinghouse on Sunday, these Riggsville families (possibly Jewetts and Campbells) were photographed by Roy Campbell while walking to their homes on the Knubble and Jewett Roads. The structures on the left were the outbuildings of the Square House, originally erected by Benjamin Riggs. Most of those additions have been torn down, and a small parking area remains near the home. (GHS.)

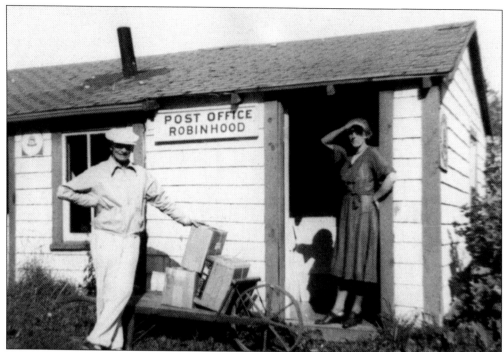

Preferring the title postmaster, Agnes Jones Powers is shown in the doorway of the summer Robinhood Post Office with customer Ernest Cochrane, about 1935. Her husband, Cal, had a workshop off to the left side of the building. In the winter, the post office was run from her nearby house, and in later years, she ran the post office in the Robinhood store. (Stella Powers Williams Collection/GHS.)

Prior to 1820, Benjamin Riggs erected his first store on the shore in front of the c. 1800 house built for his son James. Benjamin ran the 1820 store until his death in 1846. In 1923, William and Marguerite Zorach bought the James Riggs house from the Baker family, and the old store was moved to Riggsville, probably on a barge, for use as a summer cottage. Note the horses onshore. (GR.)

36

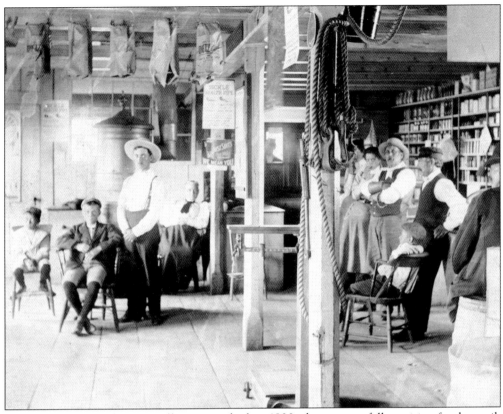

An interior view of the Riggsville store in the late 1800s shows many folks waiting for the mail. Note the steamship ticket clerk in the middle of the building at the back wall. The building, now part of Robinhood Marine Center, has been returned to new, and the three posts in the middle remain. Downstairs is now home for the machine shop that makes Spartan Marine parts. (GHS.)

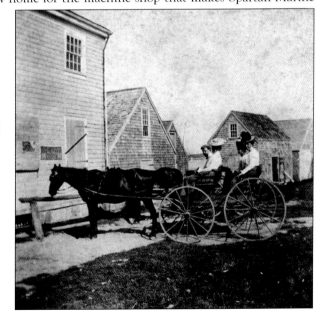

Here is the Riggsville Taxi, around 1900, with Allen Jeffrey at the reins of old Fanny, the mare, plus several attractive passengers onboard. They have a two-mile ride down the Old Stage Road to the Reynolds and Charak boardinghouses near the Mill Pond Dam on Robinhood Cove. They are leaving from the general store in Riggsville, having just disembarked from an Eastern Steamship Line boat. (GR.)

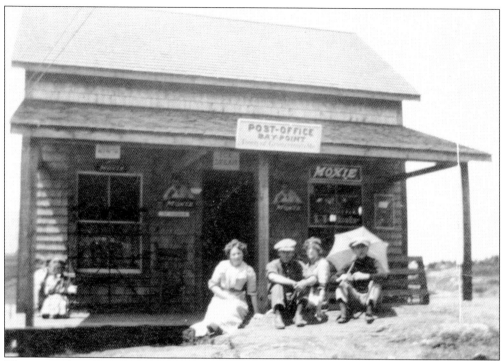

This is another example of one of the many village stores in Georgetown that also served as post offices. In front of the Bay Point Post Office, two young couples, as well as a child, enjoy refreshments, perhaps Moxie, on a hot summer afternoon. (GHS.)

The Peterson family owned this busy Robinhood store during the mid-1940s. Putting up orders for MacMahan summer customers are, from left to right, Bethena Deermont, Grace Calabrese, and the store proprietor, Phil Eaton, of Bath. The structure was taken down and rebuilt a few years ago by the owner of the Robinhood Marine Center, Andy Vavolotis, with hopes that it will last another 200 years. (GR.)

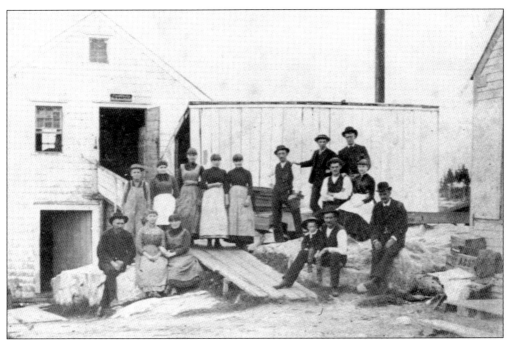

This is a great c. 1880 photograph of buildings at the wharf at Five Islands when it was used for various enterprises—and long before the second story of one building became an apartment and was renamed the Love Nest. Standing out front are a group of Five Islands workers who likely were employed canning blueberries in the summer and making various fisherman's clothing in other months. (GHS.)

This photograph, taken from the Harbor Inn, shows Five Islands village before the houses and the store were torn down. Only the wharf, bait shed, and Love Nest survived. Maud Steussey, the widow of Norm Howard, owned the 33 acres of land and buildings until she sold it to the town in 1973 for $60,000. A group of citizens raised more than half of the necessary sum from private donations. (GR.)

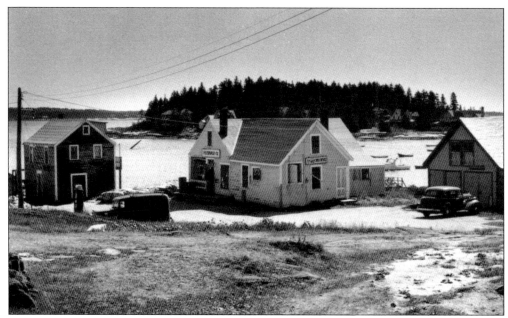

Here is the Five Islands store in the mid-1930s near the wharf and Love Nest. The Town of Georgetown now owns the entire area, and the wharf and Love Nest have been restored. Currently, the kitchen is run by the Five Islands Lobster Company and produces a great lobster roll. The old store was torn down because of asbestos, and a beautiful hot-topped parking lot has taken its place. (GR.)

This c. 1960 image shows the Love Nest on the wharf at Five Islands, which got its name years ago from the fact that the second floor had an apartment often rented to young couples. Over the years, the building has housed several businesses, including seafood packing and oilskins making. There are picnic tables on the wharf and a sign warning folks not to sit too close to the bait shed. (GHS.)

In the fall of 1950, a group gathers to help assemble the stovepipe for the kerosene stove used to warm the Five Islands store. Pictured are Fred Gray, with back to camera, and on the steps, from left to right, Percy Savage, store owner; Frank Carlton, kneeling; Harold Pinkham; unidentified man who worked on Malden Island; and Harland Harford, "Mayor of Five Islands." (GR.)

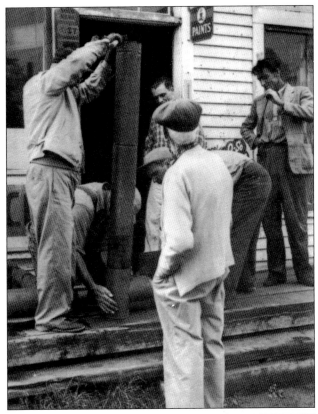

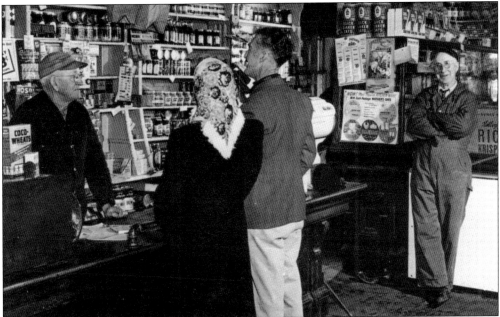

This c. 1950 photograph of the interior of the Five Islands store shows all three men who, at one time, were owners and operators of the business. They are, from left to right, Lerm Rowe, with customer Edie Pinkham Carey; Vernon Gray; and Percy Savage. (GR.)

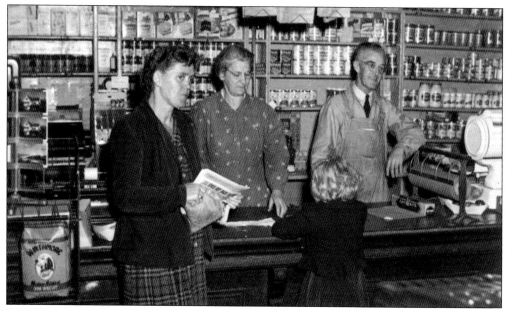

Another late-1950s interior view of the Five Islands store shows owners Addie and Vernon Gray behind the counter and customers Sally Lewis and her daughter Jill in front. Note the rack of photographs at left with postcards by Clarence White Jr., son of the famous photographer Clarence H. White, one of the early-20th-century American photography greats. At that time, postcards sold for 10¢ each. (GR.)

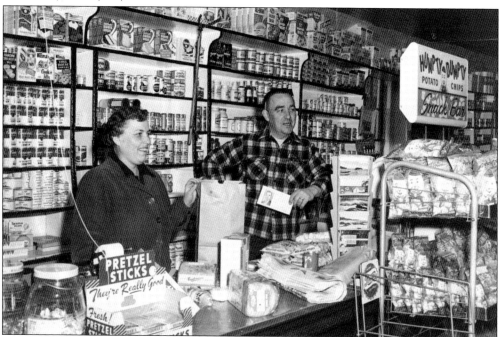

Here are Alice and Ray Grover in the early 1960s inside Grover's general store on the waterfront in Five Islands. Alice was the postmistress, bookkeeper, clerk, and partner in the operation of the store. They were a jovial couple. Like the many other operators of the Five Islands store, they were helpful and fair to their villagers with credit. (GR.)

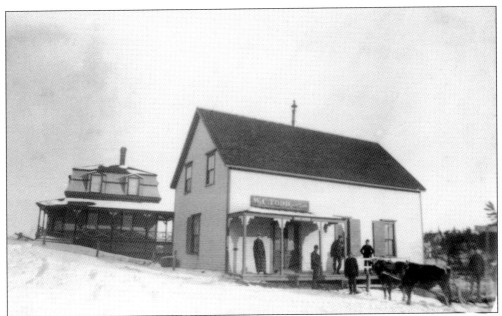

Here is a great early photograph of the W.C. Todd's general store at Georgetown Center. Note that the stairway on Knight Lane has not been built yet and there are no windows over the porch and no gas pump. Built by Warren "Clem" Todd in the mid-1800s, the general store, for several years, was operated by Clem, hired help, and his son, Will, who worked in the store from a very young age. (WT/GHS.)

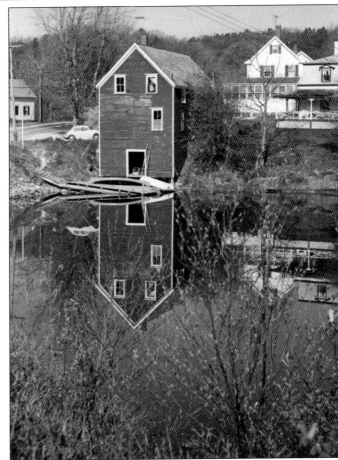

The large building in the middle of the photograph is the former Georgetown Center Todd's Store, now owned by Will Ansel, well-known professor, boatbuilder, and author. The lower section is now his boathouse. Note the picture-perfect mirror image of the scene. Some say it is the most photographed building in town. (GHS.)

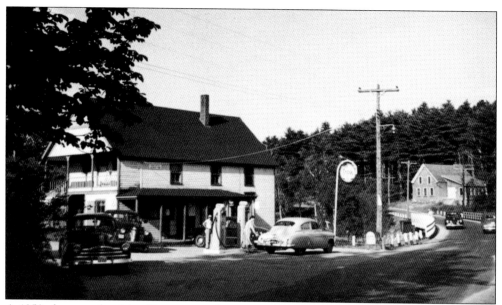

A 1950 photograph of the Georgetown Center store shows postmistress Bridie Davis pumping gas. To the right are the west bridge and old town hall, which was used as a school during World War II. In January 1944, students waiting for their bus saw a Navy plane go down in flames. In its last years, the hall was used for variety shows and as a basketball gym for the local youth. It was torn down in the 1970s. (GR.)

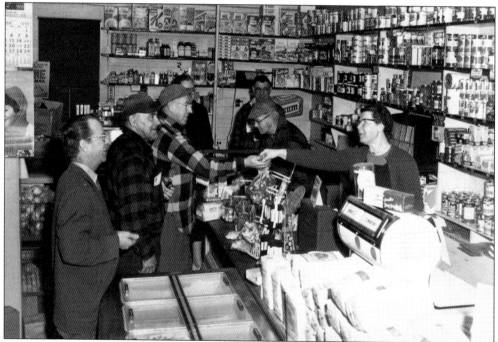

On a busy day at Todd's Store in Georgetown Center, Bridie Davis passes change to customer Everett Stevens as his brother Linwood stands beside him. On the other side of the counter, Bridie's husband, Ralph, takes care of a customer while C.S. Kelly, principal and teacher at the Georgetown Grammar School, waits his turn. (GHS.)

This was one of the last homes to burn during the great forest fire of 1934 that struck Five Islands. The house was rebuilt, and Edith and William "Hooky" Marr lived in it for many years. Edith was a teacher in the town of Georgetown's schools. Marr descendants still own the home. (Marr family.)

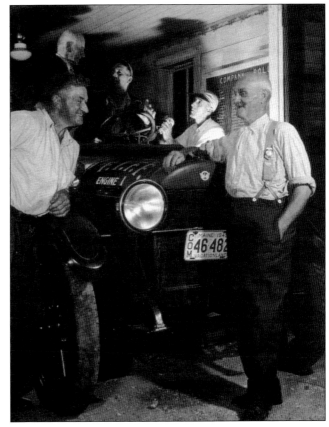

After the terrible fire of 1934, locals organized Georgetown's first fire department. Fred Carr led the effort and was the first fire chief. Initially, equipment was a tow-behind pumper. After several years, the department purchased a 1924 REO fire truck, shown here in the firehouse, the former schoolhouse and Kennebec Spruce Gum shop. Pictured in 1947 are, from left to right, Chief Carr, Frank Blake, Victor Pinkham, Gilbert Standish, and Everett Cromwell. (GR.)

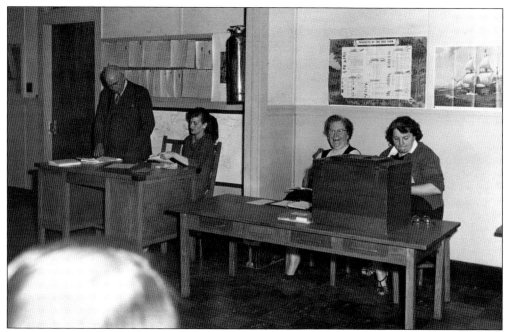

An official 1950s Georgetown Town Meeting is under way. Conducting business on the left is the unidentified moderator, with town clerk Christine Plummer and ballot clerks Ethel Higgins and Marion Watson. Election of the moderator and town officers was always the first items of business. (GHS.)

For many years, tradition was to hold the nearly daylong town meeting on Saturday, including the vote for town officers. Now, officers are elected by secret ballot on the Tuesday before and the remainder of warrant articles are addressed at a Saturday town meeting. Business is usually completed by lunchtime. Among those in attendance at this meeting are Alfred Rowe, Belle Heald, Will Todd, Maud Todd, and Arthur Marr. (GHS.)

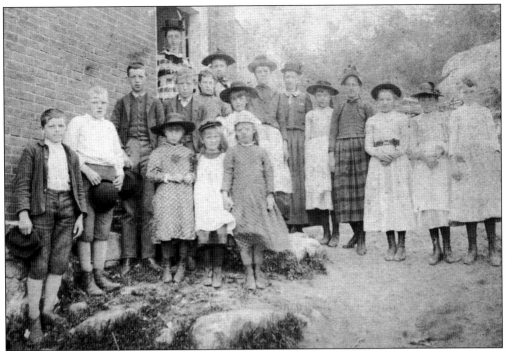

Here is an undated image of schoolchildren at the Georgetown Center School, now the Laura E. Richards Library. Many years later, in the 1940s, there were nine grades and about 40 students. Now a seasonal library managed by dedicated volunteers, it is beloved for the tradition of "Blizzard Books," which allows members to borrow as many books as they like over the winter. The challenge is to read them all by spring. (GHS.)

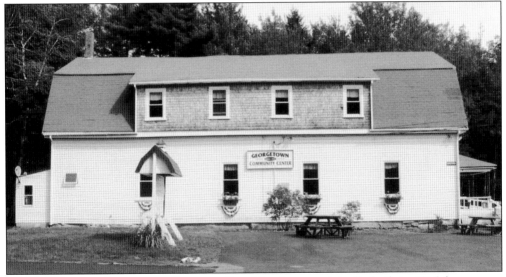

The Georgetown Community Center in Five Islands was originally built in 1915 for use as a Grange hall. After the decline in Granges, the structure was a library and then incorporated as a community center in May 1976. Thanks to a dedicated and hardworking group of volunteers, the building has been restored beyond its original glory and is open to all citizens of Georgetown. (Georgetown Community Center.)

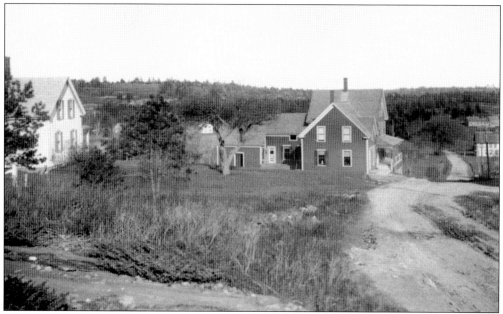

Here is Lane Hill (Route 127) in Georgetown Center heading east toward Five Islands. On the left, partway down the hill, is the home of Augustus "Gussie" Rowe, built by Benny Woodside. It was a general store and post office for many years. The postmaster's job went back and forth, depending on who won the battle for the American presidency. The business's competitor, Todd's Store, sat at the bottom of the hill. (WT/GHS.)

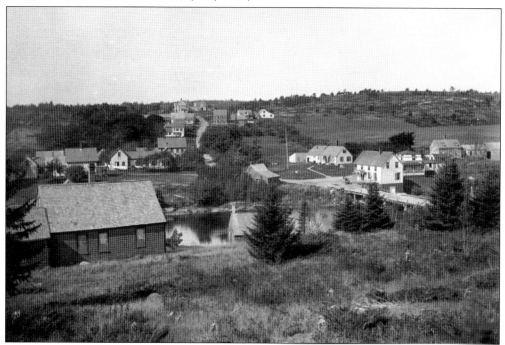

This photograph of Georgetown Center was taken from the hill behind the village, with a view looking west. Most of the houses have survived to today. Todd's Store is on the center right, and next to it is the Joe and Ethel Higgins home, before the addition of a second floor. (WT/GHS.)

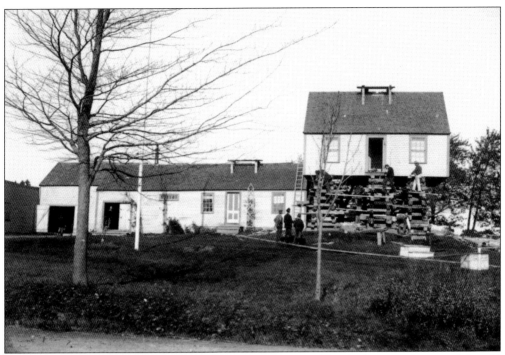

The Higgins home in Georgetown Center sits just across Knight Lane and west of the old Georgetown general store. In this picture, they are adding an addition the hard way—by jacking up the eastern main section and inserting a new first floor. (WT/GHS.)

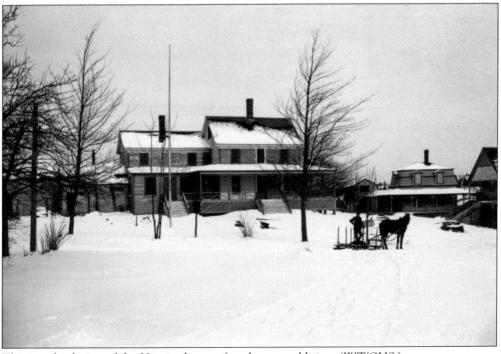

This is a third view of the Higgins home after the new addition. (WT/GHS.)

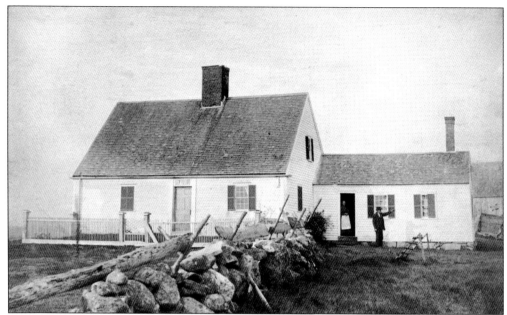

The Heald home is a typical early-1900s New England Cape Cod, which still stands in Georgetown Center, with many acres of rolling fields. The family arrived here from England in the mid-1700s. Family folklore claims their vessel was bound for Biddeford but was wrecked in the mouth of the Sheepscot River, and when forced to choose, the men opted first to save the farm animals and then their wives. (Clayton Heald.)

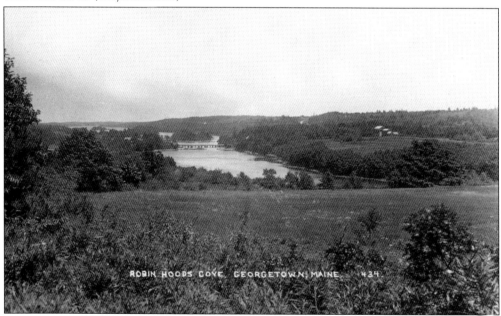

Here is Georgetown Center, in a view looking northeast from the Bay Point Oliver farm near the former First Baptist Church. Todd's Store is to the left of the west bridge, and the Trafton sawmill and Josie Oliver Newman's home are at right. During the 1940s and 1950s, Don Leavitt's company excavated thousands of yards of gravel from the field, now home to the Transfer Station and its "Georgetown Mall." (GHS.)

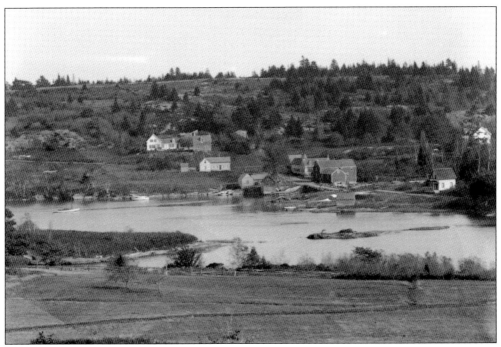

This view of the east side of Georgetown Center was taken from Knight Lane. At the very top of the high ridge, there was a road that went from Morrill's Corner (far left) on the main road to a junction with the Indian Point Road (far right). The road is now abandoned. (WT/GHS.)

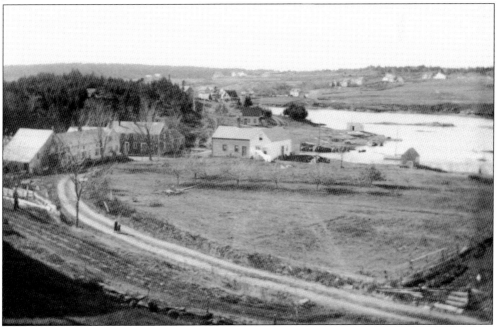

From above Harrington Hill, the view overlooks the eastern section of Georgetown Center. On the left is the Berry Shipyard, west toward Lane Hill (Route 127), and what is now the left turn onto Indian Point Road. The First Baptist Church is at top left. Today, the Georgetown Central School sits in the field opposite that same building, now called First Church. (WT/GHS.)

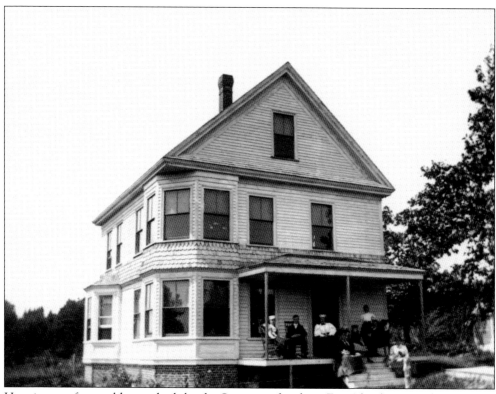

Here is one of several homes built by the Snowman family in Five Islands. Once the residence of Percy and Alice MacGillivary, it has been carefully rebuilt and is again a MacGillivary home. (WT/GHS.)

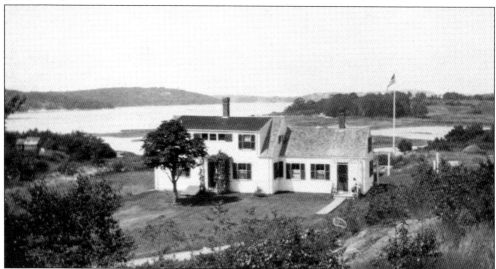

Here is the house of two Georges, situated just off the Bay Point Road on Kennebec Point. George Todd came from Scotland and was one of the earliest settlers of Georgetown. He was a sea captain who built the house in 1797 and was the great-great-grandfather of Will Todd. The second George owner was George Kahrl, a professor and chairman of the Department of English at Elmira College, New York. (GHS.)

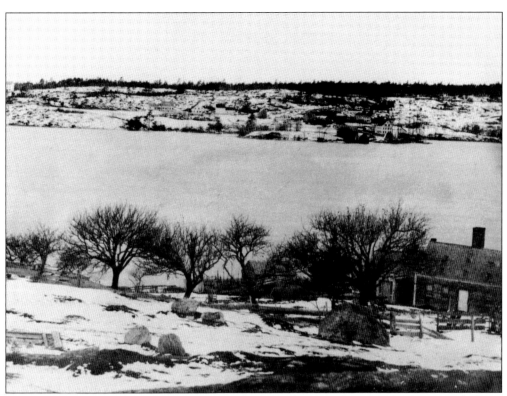

This 1860s photograph, taken from Lowe's Point with the Lowe house in the foreground, shows Riggsville from across the cove. The Free Meetinghouse is seen in the upper left with few trees. Several schooners are tied up at the wharf, and the cove is frozen over. Also shown are several Riggs homes, including the Moses Riggs's home that was moved over to the Knubble in 1985. (GHS.)

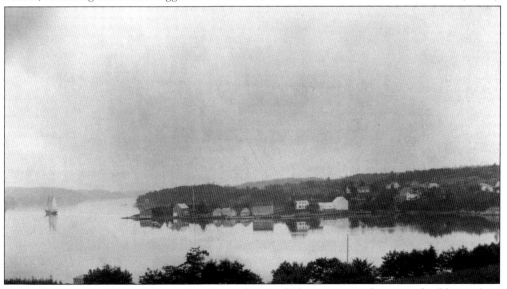

This photograph of Riggsville, taken from the Knubble, captures the many buildings that, fortunately, still stand. The warehouse on the left and one small building near the wharf are gone. All others have survived. (GHS.)

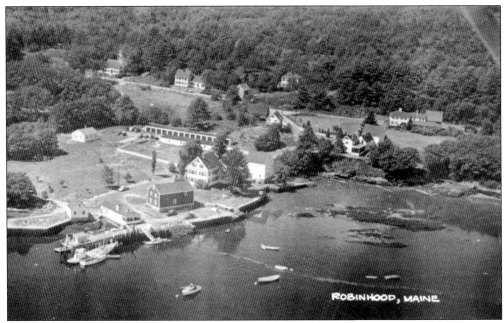

This c. 1949 aerial view of Robinhood Marina, from the Peterson era of ownership, shows most of the buildings in "downtown." The photograph was taken before the second row of rental garages was built for use by MacMahan Island folks; they had access to the ferry to the island and the grocery store. (GHS.)

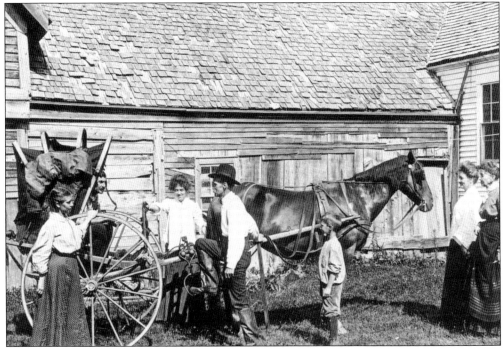

At the extreme left is Carrie Baker, daughter of Johns Riggs, outside her grandfather James Riggs's woodshed in the 1880s. Adolph and Dahlov Ipcar acquired this Riggsville house in 1937, and it remains in the family to this day. (GHS.)

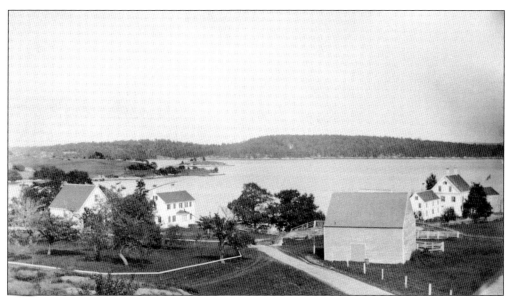

This late-1880s photograph was taken from the ledge by Agnes and Cal Powers's home of Riggsville. The barn on the right has been taken down. The Kervin Riggs (son of Moses) house is on the left. The latter still stands, although now on the outcropping across the cove, known as "the Knubble." (GR.)

After his marriage, Moses Riggs built a home near the Riggsville store. The house changed hands several times over the years, following the ownership of the store. Later owners were Levi Powers, Ned Williams, Roland Peterson, and Ralph and Sylvia Becker, who moved it to the Knubble by barge in May 1971. (GR.)

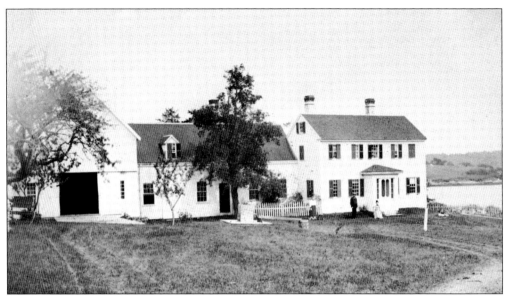

This Riggsville home, built by Benjamin Riggs and sons, was at first a home for son Moses. When his own son Kervin married and started a family, Moses gave it to him and built another house closer to the store. In later years, the old house was purchased by the Deermont family and now is the property of their grandson and his wife. (GR.)

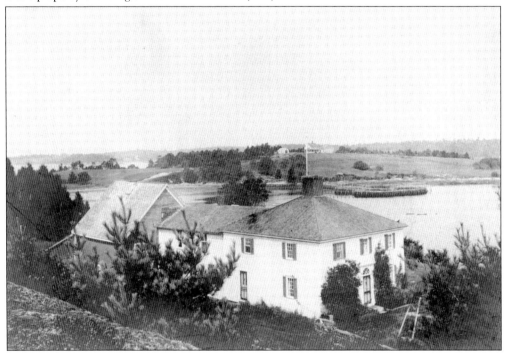

Benjamin Riggs arrived in North Georgetown (later Riggsville/Robinhood) around the mid-1760s. He fought in the American Revolution, was captured five times, and released. He bought land and married Ruth Pearl of Edgecomb in 1782. They built a log cabin and had 13 children, two of whom died at birth. Over a three-year period, they built the Square House (around 1790), which is now in the National Register of Historic Places. (GHS.)

Three

GEORGETOWN AT WORK, FACES AND PLACES

Someone once said, "If you can't find work in Georgetown, you're doing something wrong."

The traditions borne from living on an island speak to the way men and women in Georgetown approach their work. There have always been a myriad of jobs to do, a large number of these having to do with the water, like lobstering, clamming, and dragging for scallops. However, very few of the jobs available were nine-to-five, year-round. One learned at an early age to piece together a patchwork of things to make a living. If a person did not go lobstering in the winter, he might pick up a job as a snowplow driver, handyman, or carpenter. In the days when steamboats were in service, a job on a local steamer or perhaps a large steamship, going between large ports in Maine and cities like Boston or New York, would take people off the island for a while. In the days when the quarries were active in Georgetown, jobs could be found getting feldspar out of the ground. Whatever the choice, it bred a sense of self-reliance in a person.

When the artists found Georgetown, they realized that they had discovered a place where they could truly be themselves. The quiet but confident people they met on the island somehow became an inspiration to them and helped them realize new facets of their work hidden to them by the hectic pace of the cities where they lived. The artists' interaction with the people they met on the island became, in many cases, a lifelong bond. Both islander and artist enjoyed an atmosphere of mutual respect.

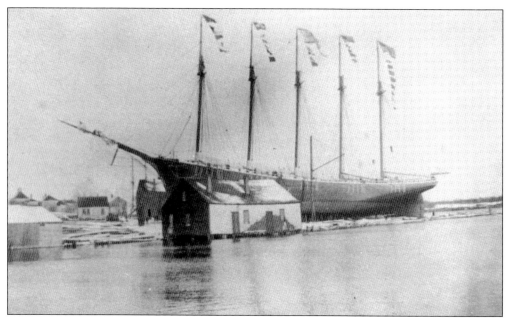

Wiscasset had the schooners the *Hesper* and *Luther Little,* two of the most photographed ships in the United States. Georgetown's *Mary F. Barrett* was another derelict sailing vessel that rotted away on the backwater shores of a lesser-traveled area and never got the fame and photographs of her well-known sisters. She was launched from here at the Gardiner Deering Shipyard in Bath, Maine, on November 26, 1901. (MMM.)

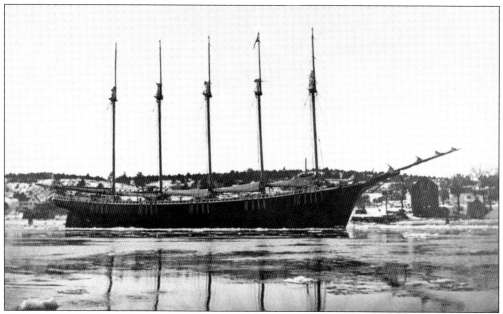

This photograph shows the *Barrett* moored off the Deering Shipyard, ready to go to work. She would only have had ballast in her holds if the company were unable to get a shipment south. Her first captain was R.B. Sargent, a veteran skipper who would handle well the big five-master. Her gross weight was 1,833 tons, and she was 241 feet long, 43 feet wide, and had a draft of 24.5 feet. (MMM.)

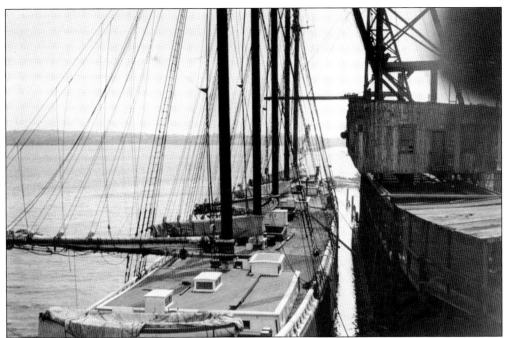

Here is the *Mary F. Barrett* loading coal at Hampton Roads, Virginia, in February 1922. The Deering Shipyard built three five-masters, with financial support from Braman Dow Company of Boston. Henry O. Barrett was the firm's president, and many ships were named for Barrett relatives. Mary F. was Henry's wife. Another five-master, the *Dorothy Barrett* was sunk in 1918 by the German submarine *U-117*. (MMM.)

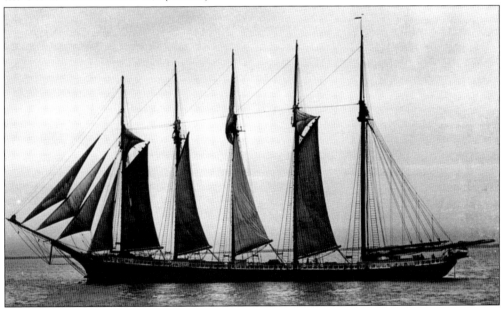

The *Mary F. Barrett* did not have a very glamorous career, spending most of her years carrying coal for the Deering accounts. In this photograph, she is in the Kennebec, waiting for a tug to haul her upriver. She never had any major collisions or troubles—other than a cook going berserk and attacking the crew with a meat cleaver; the captain shot him. (MMM.)

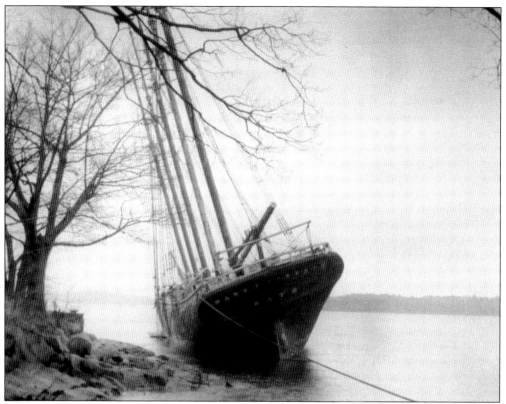

Here is the once proud sailing ship, the *Mary F. Barrett*, behind what is now the Maine Maritime Museum. In 1927, her sale at auction brought no buyers. During a storm, she broke her lines and drifted out into the river, but quick work by a tug brought her back to shore. At the ripe old age of 25, her sailing days were done. (MMM.)

Shown around 1927 is the *Barrett* with her masts cut down, being hauled by the tug *Seguin* into Robinhood Cove. Owner Joe Totman's plans to ground her on the Knubble for easier salvage were met by Burnside and Levi Powers and sons who, with shotguns, persuaded Totman to beach her across the cove on his own North Five Islands property, where she rotted away. (Family of Stella Powers Williams/GHS.)

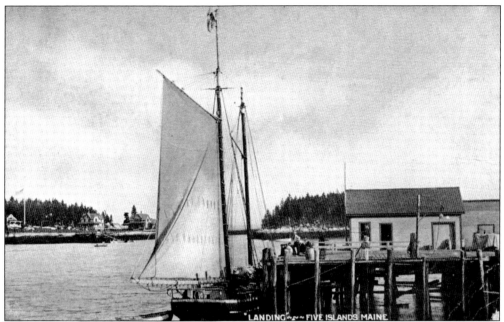

This July 1907 view of the Five Islands Wharf shows the two-masted coaster *Myra Sears* of Bristol. Since then, the wharf and accompanying buildings have been rebuilt and enlarged considerably. Note two of the Five Islands in the background, Malden and Hen. A group from Malden, Massachusetts, and Topsham, Maine, bought these two islands from Moses Riggs for $190 in 1871. (GR.)

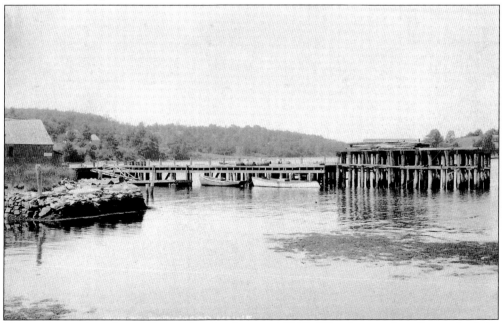

This is the newly enlarged Riggsville wharf, around 1905. Wharf owner Levi Powers had the Woolwich firm of Frank Carlton do the work for the princely sum of $10,000. In 1928, Frank Carlton's crew built the Cribstone Bridge in Harpswell. It also lifted the Woolwich-Arrowsic Bridge out of the Sasanoa River when it sank in 1916. (GR.)

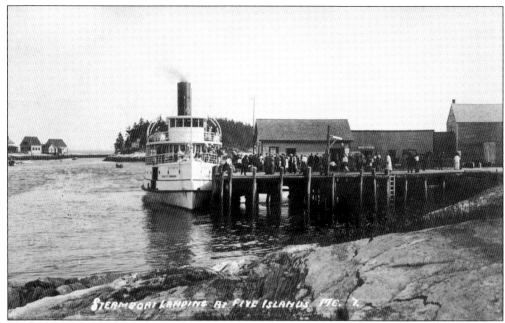

Business was good in 1911 for Five Islands and the Eastern Steamship Company. A larger steamer was used for several summers, and the *Southport* fit the bill. She and her sister ship, the *Westport*, worked the Kennebec and Sheepscot ports. Both were transferred down east to the Rockland Line after nine years. (GR.)

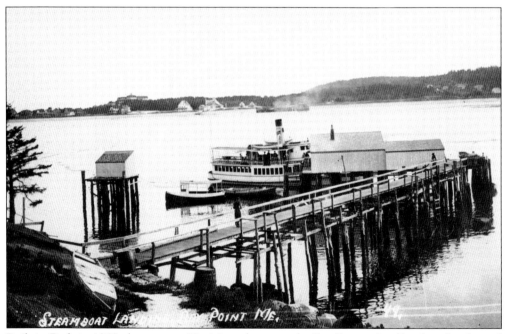

Built in Bath in 1909, the steamer *Virginia* is shown at the Bay Point wharf loading freight and passengers for a trip upriver to Bath. Phippsburg's Popham Beach is seen across the Kennebec River, with the lighthouse station and the Rockledge Hotel in upper left. The hotel, built in 1881, had 100 rooms and burned in 1915. (GR.)

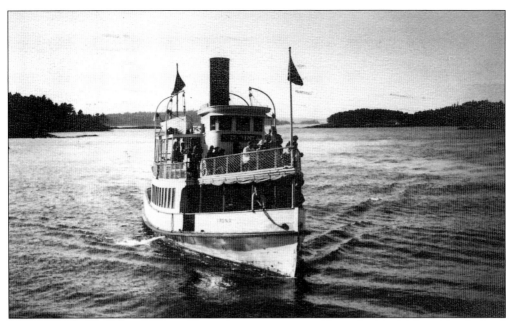

In 1938, the beautiful steamer *Virginia* is shown moving swiftly to the MacMahan Island wharf. She made this run for many years from Boothbay to Bath, with numerous stops at villages along the route, where she picked up and delivered passengers and freight and then headed for Five Islands. Her turnaround times were fantastic, and she ran until 1941. The north end of Five Islands is on the left, and Westport Island is on the right. (GR.)

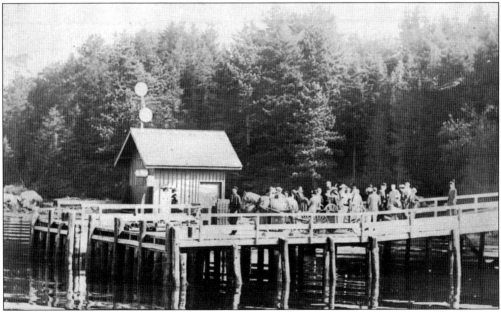

In 1982, Margaret Whittemore Lee wrote in the *Georgetown Tide*, "The first summer we were here, 1899, there was no water in the cottages . . . groceries came from Lermond Rowe's store at Five Islands . . . The day's main event was when we went down to the wharf on the Little Sheepscot and met the steamer on its route to Bath or Boothbay." Shown with horse and wagon is attendant George Gray of Five Islands. (GR.)

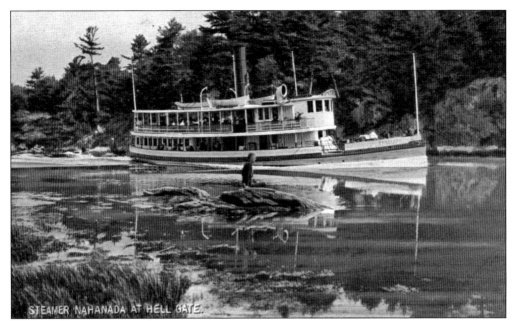

STEAMER NAHANADA AT HELL GATE.

In the mid-1800s, when the rivers were the roads, the steamboats were one of the fastest means of transportation. The Eastern Steamship Company was the largest and longest in service. Shown here is the *Nahanada*, deftly and safely shooting through Hell's Gate passage on the Sasanoa River, headed from Riggsville to Bath. She ran the Bath-to-Boothbay route for 35 years. (GR.)

Shown here is the Lowe House on Robinhood Cove at the northern tip of Five Islands. The Lowe brothers were steamship captains for the Eastern Steamship Line. It is the house in the famous fable about the giant halibut that swam into the cellar during an especially high tide and went out a window before it could be caught. (GHS.)

BEAUTIFUL
EXCURSION
FROM FIVE ISLANDS
TO FORT POPHAM
FRIDAY, AUG. 15
ON STMR. SASANOA.

This Trip will give a fine opportunity for a stroll on the Delightful Beach and enjoy the Grand Sea View.

Steamer leaves Five Islands at 10 A. M.; returning leaves Fort Popham at 3 P. M.

FARE, ROUND TRIP, 35 CENTS.

A local Georgetown Historical Society member has a collection of nearly 100 "steamship broadsides." They have survived for over 130 years, weathering rainstorms and vandals. They were printed daily to announce the schedule of the steamers for passengers, both summer folks and local workers, around the Bath and Boothbay areas. Most in the collection, printed on onionskin paper, are from the 1880s. Steamers lasted from the mid-1850s to the early 1940s. Now, the broadsides are gone, and so are the steamers and their ships bells. Some may remember their jingle. According to Richard Hallett in *Kennebec-Boothbay Harbor Steamboat Album* (1971), "two bells for going astern, one for going ahead, and then—the jingle. That meant full speed ahead; it also meant, all finished with the engines." The collector says, wryly, that at least three other people in the country are interested in them. (GR.)

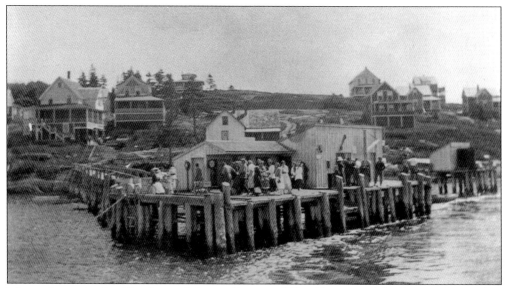

Many who arrived at Bay Point did so at Spinney Wharf by way of the Eastern Steamship Company's Bath to Popham boat. In 2004, John L. "Jack" Swift shared his recollections, saying, "Herm's [Spinney] wharf was the Bay Point village dock, where in addition to the daily arrivals of the mail boat, he bought and sold fish and provided a place for small boys to fish and tether their skiffs . . . Ralph [brother to Herm] sold gasoline for the inboard motors of the fishermen and lobstermen, bought and sold lobsters and clams, smuggled liquor during Prohibition and operated a row of 'one-armed bandits' in the back room of his wharf." (GHS.)

This c. 1930 view of Bay Point, without any steamers at the wharf, shows the wharf and buildings in good shape. The long one-story building in the lower right is the Spinney family's Duck Inn Lunch. Some of the local men in the village, and many others from out of town, liked to assemble there to play games of chance. Note Clark's Hotel on the point of Long Island. (GR.)

The five Spinney brothers—Fred, Morris, Ernest, Ralph, and Herman—are shown standing, in no particular order, by a Bay Point ledge. They owned several watercraft that they used in their various business ventures. Some folks said they had a "fast one" in a boathouse in Marrtown. The brothers were known in their time—and to this day—for their many enterprises in Bay Point during Prohibition days. (GHS.)

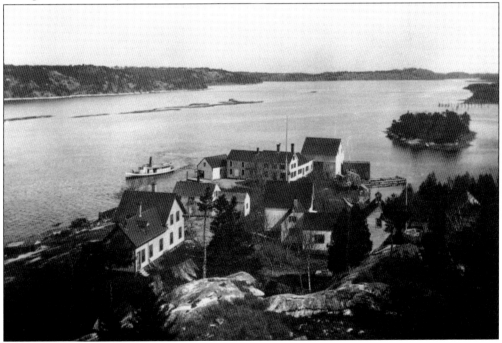

This 1920s view shows a steamer leaving Hinckley's Landing at West Georgetown on the Kennebec River, heading downriver toward landings at Georgetown's Bay Point and Phippsburg's Popham. (GHS.)

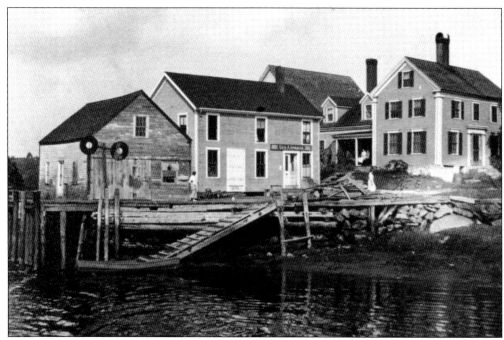

This c. 1900 photograph at West Georgetown shows where the steamers of the Kennebec Steamship Company stopped at Hinckley's Landing "on call." Note the position of the semaphore on the dock at left. In that position, it means "no freight or passengers"; when straight up and down, it meant "come in to the wharf." (GHS.)

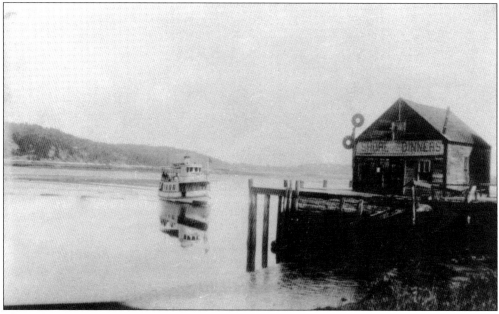

The *Sabino* is coming into Hinckley's Landing. When the steamer was known as the *Tourist*, she was caught in a riptide at the Damariscotta Bridge. She sank, drowning the engineer who was trapped below. She was raised, rebuilt, renamed *Sabino*, and guided by Capt. James Perkins. She sails still at the Mystic River Museum in Connecticut. (GR.)

Legendary fisherman Carroll "Cal" Powers is standing in a dory-load of herring in Robinhood Cove. The Knubble is behind him. Folks sometimes ask, "Why do fishermen stand in a bucket with their dory full of fish?" The answer might be, "Wouldn't you?" (GHS.)

A Marlboro man and a true old-timer, veteran Five Islands fisherman Phil Campbell enjoys a smoke while working on his lobster boat in this photograph by Clarence White Jr. He also was a duck-hunting guide for Walter Reid. (GHS.)

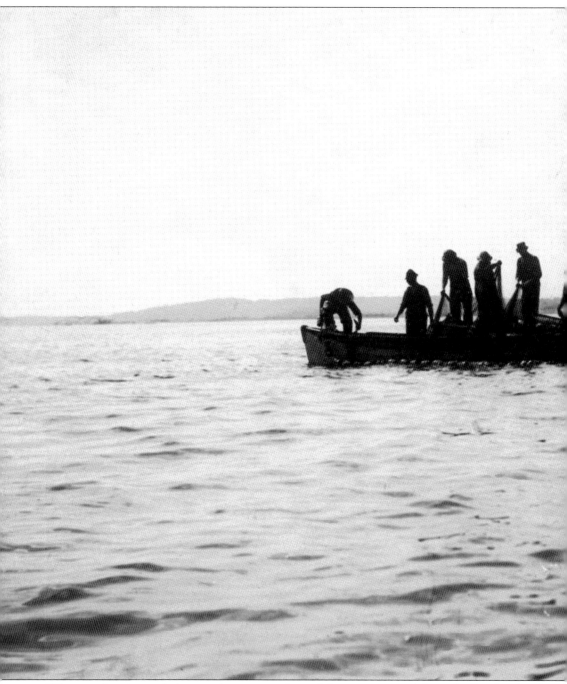

Silhouetted against a darkening sky, a crew of area fishermen—several from the Pye family of Small Point in Phippsburg—working from dories is hauling in seines full of herring. Seine fishing employs a net that hangs vertically in the water with its bottom weighed down and the top buoyed by floats. A seine-line passes through rings at the bottom, and when pulled, it prevents the fish

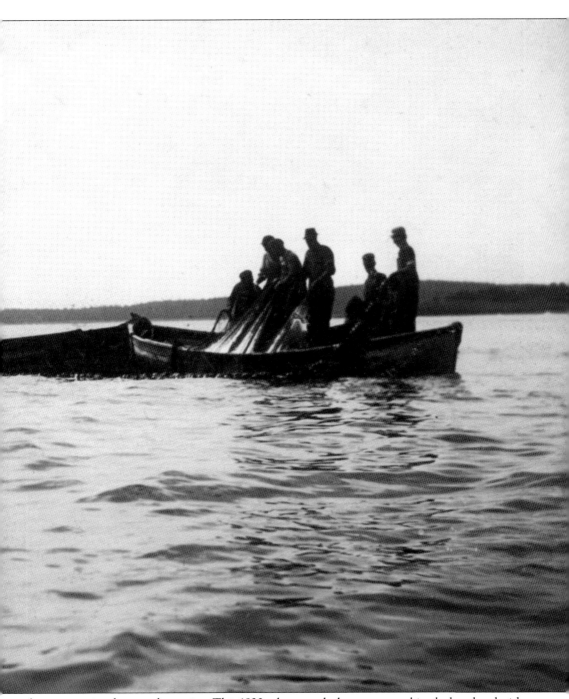

from swimming down and escaping. This 1920s photograph shows men working by hand and with their pulleys to harvest a large pocket of fish near Seguin Island, with the Phippsburg coastline in the distance. (GHS.)

This fish weir, belonging to Levi Powers and then his son Cal Powers, was off the Robinhood shore where the Zorach boathouse stands. It was one of many fish weirs the Powers men built in and around Robinhood Cove. When he and his family summered here, artist William Zorach painted them many times over the years. (GR.)

A crayon drawing by Ethan Russell depicts an early fishing station on Salter's Island in the mouth of the Kennebec River. Diggings have shown European fishermen had a fish processing business in the late 1500s to dress, salt, and pack cod, hake, halibut, and others to take back to home ports. (GR.)

It was a typical day of fishing off Georgetown Island in 1888. Gutting and cleaning several large codfish are, from left to right, Herbert Oliver, Will Todd, and Howard Trafton. Trafton is 22 years old in this picture. (Virginia Hopcroft and Susan Bradstreet.)

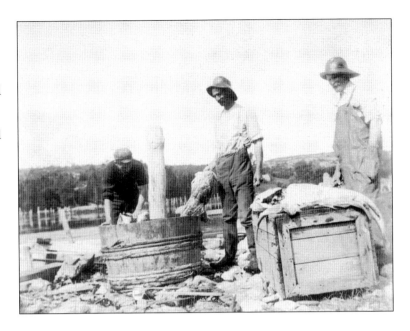

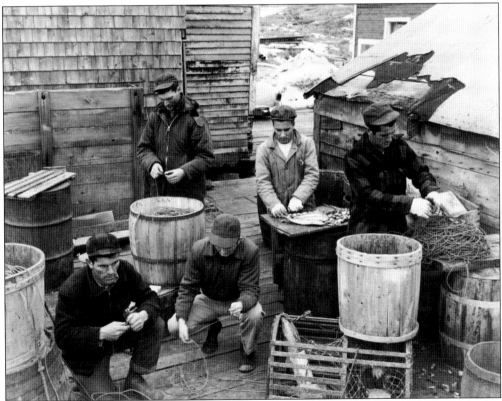

This c. 1950 photograph, taken at Five Islands Wharf, captures a cold winter's day in the life of fishermen, which included shucking clams, dressing fish, untying lines, and replacing hooks. Pictured are, from left to right, Jim MacMahan, Dennis Moore, Richard Hanna (kneeling), Lynn MacMahan, and Chester MacMahan Jr. (GHS.)

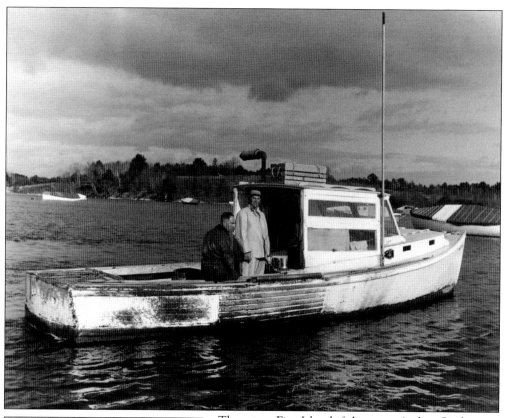

These two Five Islands fishermen, Arthur Cochrane (left) and Maynard Thibodeau, are leaving the Robinhood wharf after conducting some business. The Knubble is in the background. Take note that the pleasure boat at the mooring ahead of them is covered with tarps and plastic, apparently nearing the end of the pleasure boating season, but not the commercial fishing season. (GHS.)

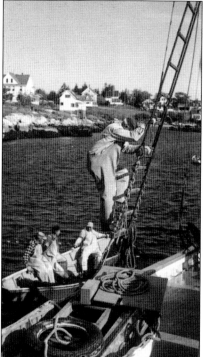

Lynwood Stevens (left), Arthur Cochrane (center), and Everett Stevens are shown here in a dory beside a sardine carrier (probably the *Ruth Mary*), just below the Five Islands Inn. The Stevens brothers worked very closely with the Bath Canning Company. Shown climbing down the rigging after some repairs is Lawrence Lowell, who worked with the Stevenses for several years. (GR.)

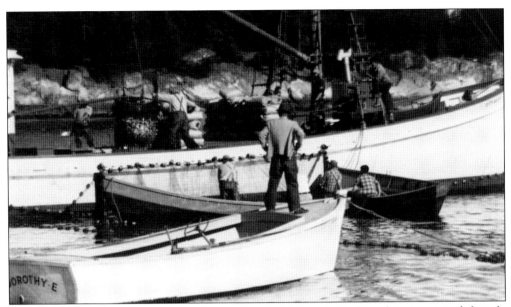

Here is another photograph of a sardine carrier in Harmon's Harbor; this time it is definitely the *Ruth Mary* out of the Stinson cannery in Bath. Men are bailing sardines out of the Stevens brothers' nets. Note the "Mayor of Five Islands" Harland Harford supervising their efforts while standing precariously on the bow of a small workboat. (GHS.)

Fishermen William "Bill" Plummer III (right) and Arthur Tibbetts are work in their Bay Point workshop, getting ready for lobster season by building and painting new wooden traps. This photograph and several others were published in an issue of *Down East* magazine. Tibbetts had a lifelong successful career as a lobsterman, and Plummer started Sheepscot Bay Boat Company in Five Islands. (GHS.)

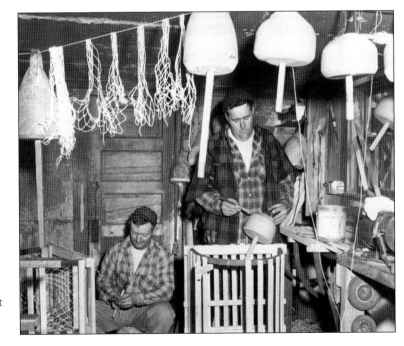

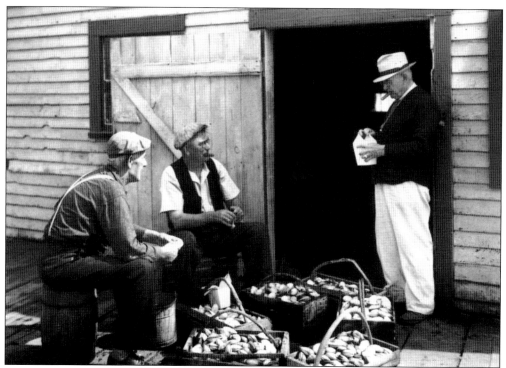

Two area professional photographers took a unique pair of c. 1955 photographs. The first is by George French of Brunswick, showing Maurice Pinkham (center) and Fred Gray (left) shucking clams on the wharf. The third man in the doorway is Norm Howard. Howard owned the wharf, store, several adjacent buildings, and many acres of public land, which his widow sold to the Town of Georgetown. (Maine State Archives, George French Collection.)

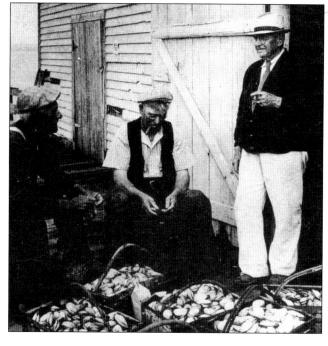

This second photograph by Bill Tinkham, of Bath and Georgetown, was taken within a few minutes of that by George French. (GR.)

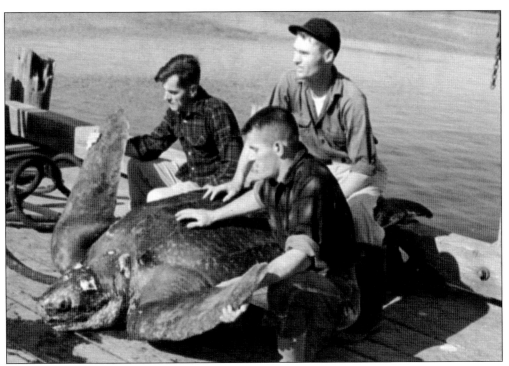

About 1950, a large leatherback sea turtle is displayed on the wharf at Five Islands, having been caught by lobsterman Dennis Moore, pictured in the middle. Brothers Chester MacMahan, on the left, and James MacMahan, on the right, helped get it out of Dennis's boat by winching it up to the wharf. (GHS.)

This 1960s photograph is of local fisherman Clarence "Chipper" Preble, who, then and now, lives on Oak Road in Five Islands and works out of Harmon's Harbor. Photographer Bill Tinkham captured him doing wheelies with his oars as he rowed to his boat. (GHS.)

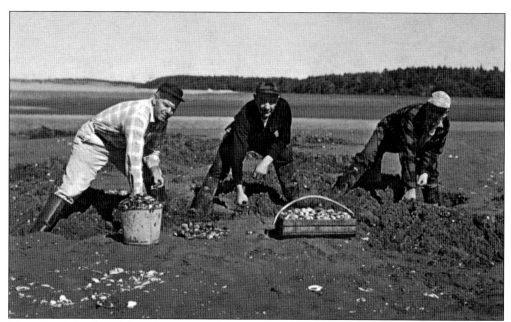

Three Five Islands Pinkham brothers are pictured around 1946 as they dig for steamer clams out on the "outer bed" at Little River. Posing are, from left to right, Philip, Ardeen, and Harland Pinkham. The image was taken by Lyman Owen, another Georgetown-based photographer. (GR.)

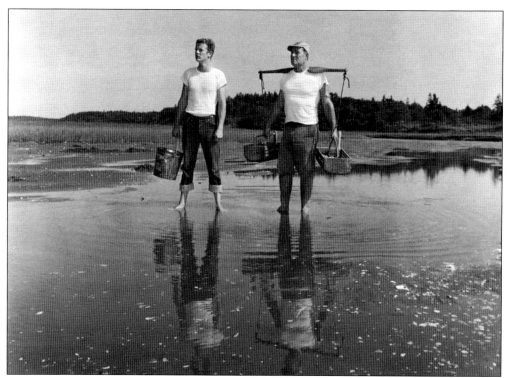

Two veteran clam diggers, Sumner Mains, on the right, and his son Cecil, on the left, are hard at work on the Sagadahoc Bay flats. (GHS.)

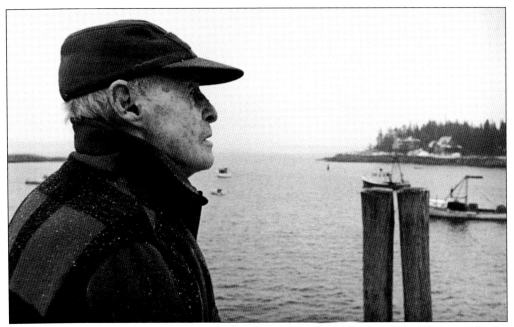

Capt. Stinson Davis of Five Islands is looking out to Malden Island and the Sheepscot River. Holding an unlimited masters license, Davis was one of the last deepwater sailing captains who sailed the seven seas. He retired in his fifties to a farm in New Hampshire and then later returned to his hometown and the family house on Harmon's Harbor. He lived to the age of 103. (GHS.)

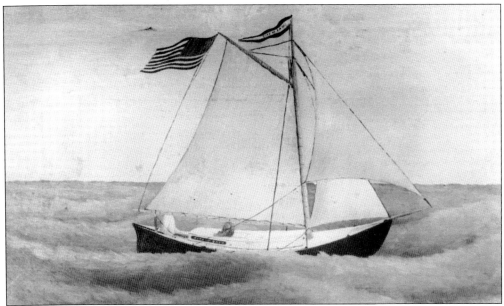

In 1881, boatbuilder Benjamin Williams of West Georgetown built a 14-foot dory for Norwegian Ivar Olsen and Irishman John Traynor. Rowing and sailing it from Bath, Maine, they crossed the Atlantic in 55 days, a record at that time. After landing in England, they crossed the English Channel to France to a great welcome. On a second trip in 1884, Traynor disappeared. The full story is available at the Georgetown Historical Society. This image is from an 1851 painting by W.F. Marr. (GR.)

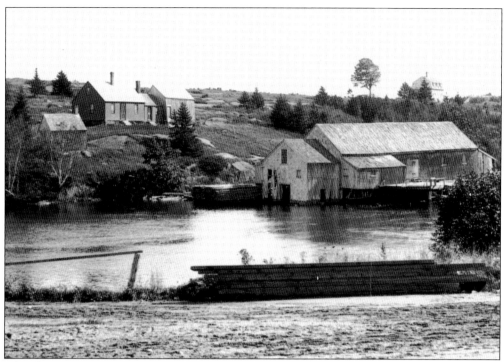

The old Trafton sawmill at Georgetown Center was the second one the family built. The first was on the east branch of Robinhood Cove, down the Indian Point Road and across from the Berry/Horne home. The mill is gone, but the dam is still in the same place. The Horne family found and saved the millstone from that dam. (GHS.)

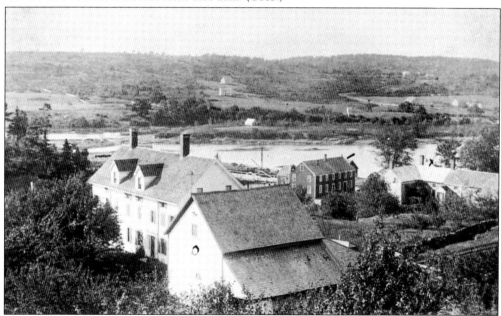

The large home in the center of the photograph was built as a boardinghouse to serve the large crew of shipbuilders at the Berry Shipyard at Georgetown Center. The 20-room house later became home to a Dr. Steadman. Sadly, it burned in 1913. (GHS.)

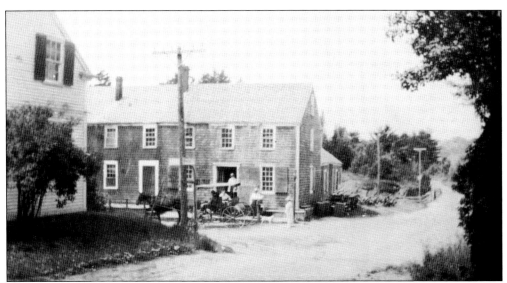

The A.K.P. Oliver general store was at the end of the East Bridge in Georgetown Center, located on the corner of what are now Route 127 and Indian Point Road. The horse and buggy in front of the store belong to Tom Williams of West Georgetown, and his daughter Babe (Williams) Gunnell is driving it. The store was originally part of the Berry Shipyard. (GR.)

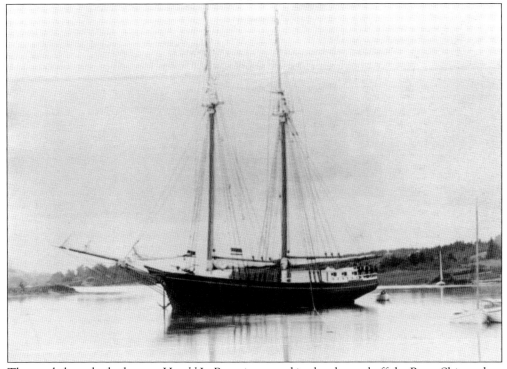

The newly launched schooner *Harold L. Berry* is moored in the channel off the Berry Shipyard on September 29, 1890. She was the last ship to be launched from there. *Baker's History of Maritime Bath and the Kennebec* has this ship being built in Arrowsic. Her owner and builder Charles C. Crosby was from Arrowsic, but she was built in Georgetown. John Harford of Five Islands was the captain. (GR.)

Walter Reid, "the Boy Wonder of Wall Street," invested much of his time and money in buildings at Harmon's Harbor. His first purchase was a small cottage, which he bought and remodeled. The last improvement he made around 1930 was the so-called Spanish Room. The family has kept the room in original condition, now as a place where B and B guests can gather. (Barabe family.)

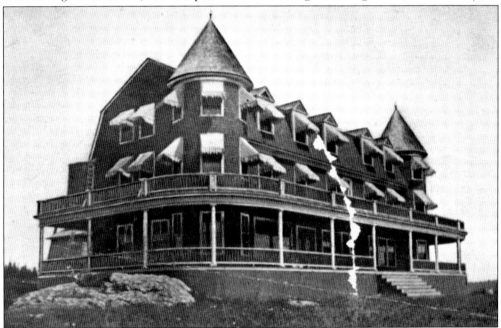

The Seguinland Hotel, now the Grey Havens Inn, was one of Walter Reid's first building projects at Harmon's Harbor. The three-story, 36-room hotel has had numerous owners since opening in 1905. At times, it sat unused and possibly at risk of being lost. It survived, and the newest owners have made it a welcoming place for guests and locals. It was Reid who renamed this area Seguinland. (GHS.)

Moored in Harmon's Harbor around 1927, Walter Reid's impressive four-masted schooner *Bright* served as both commercial vessel and private boat. His Seguinland Hotel was very successful, but the wharf he built for commercial boats and steamers for delivering guests did not do well. The next year, only the Eastern steamship M & M came in. The small boat to the left is the *Popple*, which young Clarence White Jr. used to ferry passengers from Five Islands to the hotel. (GHS.)

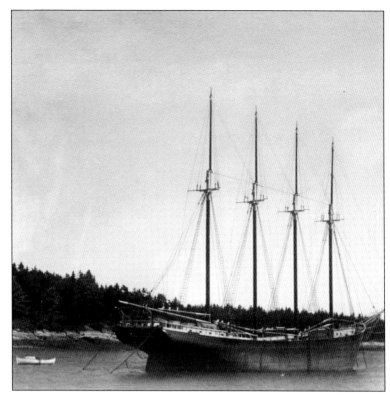

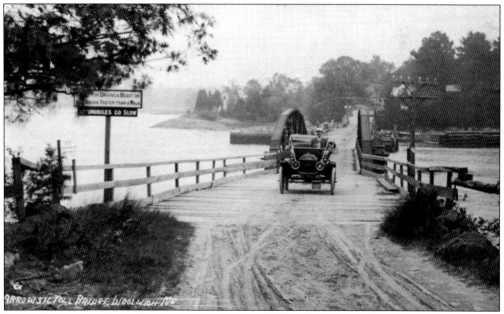

Legend has it that this well-known photograph is of Walter Reid driving his automobile across the Woolwich-Arrowsic Bridge. Reid had problems with the toll that Philip Day, the bridge tender, was required to collect; Arrowsic folks paid nothing, but Georgetown residents had to pay. Reid often ran the gauntlet, by racing by Day without payment. His and others' complaints were eventually heard, and the toll was withdrawn. (GR.)

Will Field and his dog head home down Oak Road in Five Islands after a day's work with his scythe. Another one of Bill Tinkham's great photographs, this was published by *Down East* magazine. (GHS.)

Still standing today is Will Field's boat shop on the east shore of Harmon's Harbor. Bill Tinkham captured this scene. (GHS.)

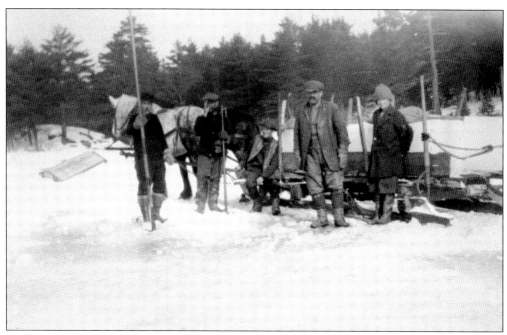

In the 1920s, the Powers family and helpers are cutting ice on Nichol (now Clarey) Pond. Pictured are, from left to right, two unidentified men, Cal Powers (seated), Levi Powers, and Stella Powers (later Williams). Before the invention of refrigerators, Robinhood was the local center for ice-cutting. To transport the ice, workers used a long wooden sluice that ran along the road to the wharf, where ice was then loaded onto schooners. (GHS.)

For their 1950s Christmas card, artist Dahlov Ipcar used her drawing of her husband, Adolph (in plaid shirt), and another man cutting blocks of ice on Nichol Pond in Robinhood. Many local farmers continued the ice-cutting business into later years. Gilbert Lewis of Georgetown Center was perhaps the last to peddle ice around the island as late as the mid-1950s. (GR.)

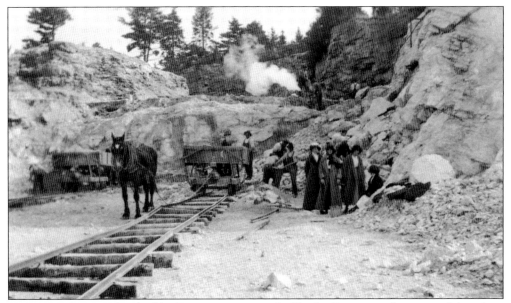

A minister from England, Elder Bracet, visiting with Charles Brown, took notice of the white ledge near Brown's home in Bay Point. Bracet recognized it as feldspar and then contacted the Golding Mining family in Trenton, New Jersey. They needed feldspar to make their pottery, which led them to invest in the removal of over one million tons over 60 years, from 1865 to 1925. (MCB&SDH/GHS.)

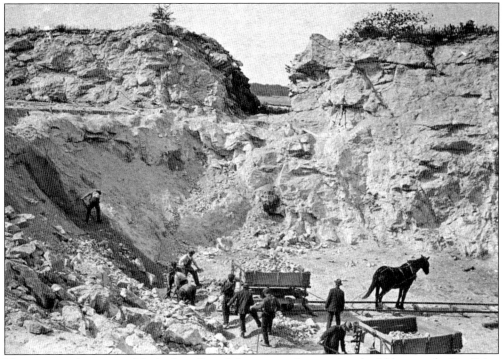

Here is a revealing view of the high walls and the means of processing the feldspar at the Bay Point quarry around 1900. Workers are loading a small railcar using the "one horsepower engine" used to pull the load, which later would be transferred onto a waiting sailing vessel. (MCB&SDH/GHS.)

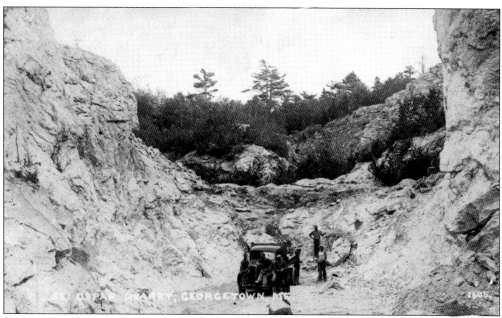

After the Golding Company left the Bay Point feldspar quarry, locals continued the mining activity at the quarry. With his dump truck, Alex Cunningham and several other workers, including Gus Collins and Alvah Reynolds, are seen taking a break from picking up smaller feldspar remnants. They loaded the truck and sold the remnants for road building. MaineMoss, owned by the Collins family, is still mining the site. (MCB&SDH/GHS.)

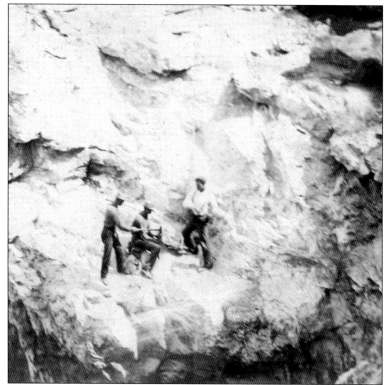

Three different techniques were used for drilling holes for explosives during the history of the Golding's quarry at Bay Point: hand drills, steam engine drills, and air compressors. Here, three men are using the hand drill method, with sledgehammers, for drilling the four-to-six-inch-diameter holes for the black powder. This extremely difficult and dangerous work was made much easier and safer with the coming of air compressors and dynamite. (GHS.)

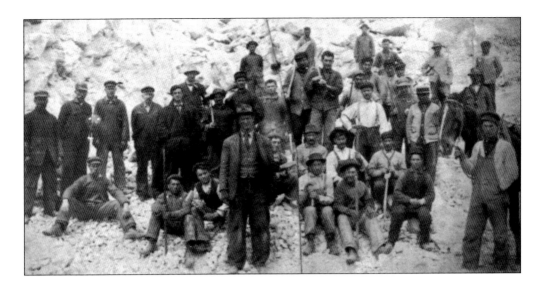

The Bay Point quarry was, and still is, an excellent source of feldspar in the United States. The stone was blasted out with dynamite, broken into smaller pieces, hauled to a wharf on the Kennebec shore, loaded into barges, and later off-loaded into freighters. The freighters took the feldspar to plants in New Jersey that turned it into glass dinnerware.The Golding Company brought several of its experienced quarry workers, and also hired local workers for about a dollar a day to work the feldspar mine. The Golding quarry workers were mostly Italians, experienced in drilling and handling dynamite. Italian quarry workers lived in sod huts that were built in a nearby field. Over $2,000,000 worth was mined in 60 years. (Both, MCB&SDH/GHS.)

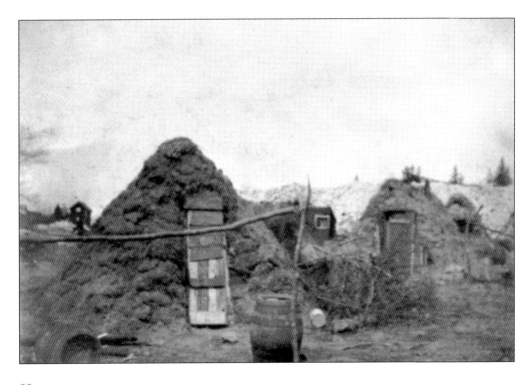

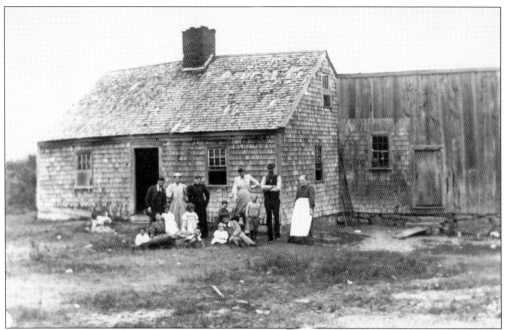

This c. 1900 hardscrabble farm, a typical Maine farmhouse of the times, shows the occupants of several generations posing for the camera. This home was on what is now Route 127 just north of Mountainside Cemetery, and it was later replaced by the Higgins' large two-and-a-half story building. (WT/GHS.)

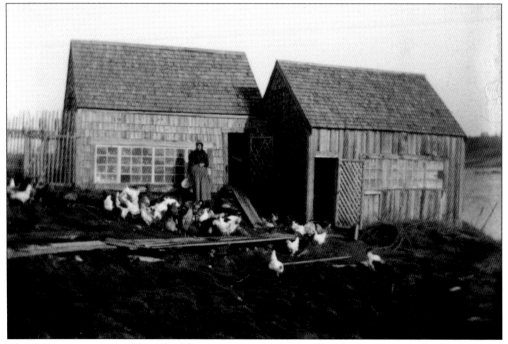

This picturesque pair of farm buildings sits on what looks like the southern end of Robinhood Cove. The tall lady feeding the hens could be the hardworking mother of several successful, well-known Georgetown citizens. (WT/GHS.)

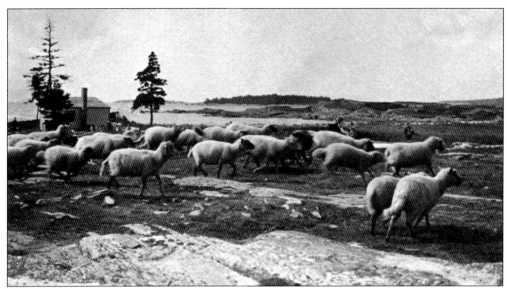

There were at least four large sheep farms on Georgetown Island in the early years. Sheep made great lawn mowers and trash-tree cutters. This sheep farm was on Indian Point, and there were others on Kennebec Point; in West Georgetown, owned by the Williams family; and a very large one on Webber Point and Island on the north end of Georgetown. They were truly free-range critters. (WT/GHS.)

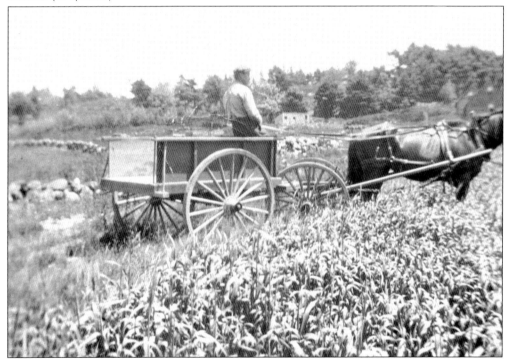

Here, Alvah Reynolds, a Georgetown farmer is shown in his new wagon in 1915. Two years later, Reynolds would find himself in General Pershing's Yankee Division, fighting his way toward Germany. A mortar shell landing in his machine gun nest would kill three of his buddies and seriously wound him in the Battle of St. Mihiel. He would spend two years recovering. (GR.)

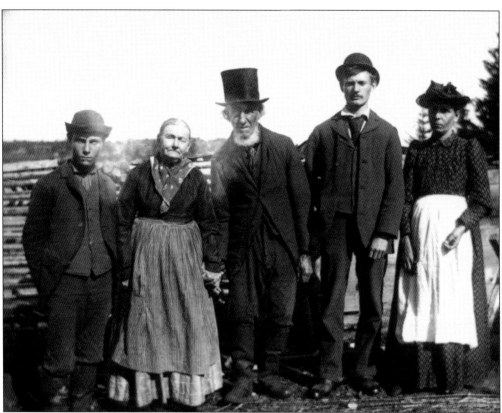

A fine-looking c. 1900 group of early settlers is modeling clothing from New York designers. (GHS.)

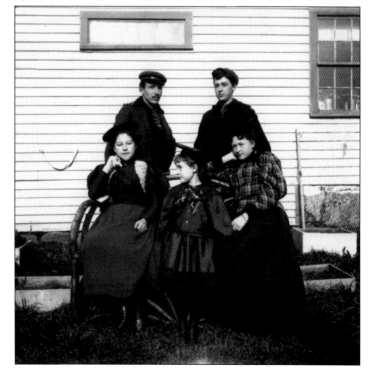

Shown in this portrait is the William Todd family. They are, from left to right, (sitting) sisters Mabel, Bess, and Ethel; (standing) brothers William and Ross. Since William was the photographer, he must have used a timer to get in the picture. He was a talented early-1900s local amateur photographer. The Georgetown Historical Society developed hundreds of his glass-plate negatives, and they are used frequently in this book. (WT/GHS.)

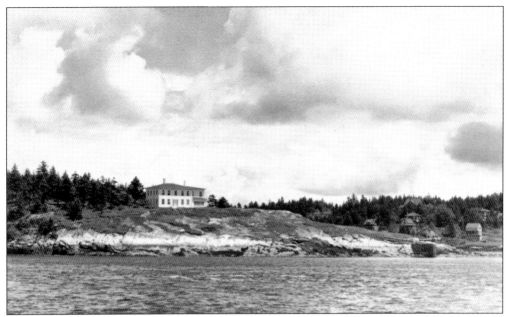

The former Clark Hotel on the southern tip of Long Island was used as a private home when owned by the artist Stephen Etnier and his wife, Elizabeth. They spent their honeymoon there. She wrote an account of their summers on this point called *On Gilbert's Head*, published in 1937. It is still a very interesting book. (GR.)

Keeping warm by the kitchen woodstove on a Saturday night is nine-month-old Gordon Pinkham. He sits in the galvanized washtub asking to have his back washed. His mother likely told him that happens just once a month in 1947. (Denise Moore Reynolds.)

Born in 1878, Josephine Oliver Newman was the daughter of Georgetown native Sewall Parker Oliver and Florence Holman Oliver. When she was a child, her parents purchased a Georgetown farm and moved the family there. She had a lifelong interest in biology and botany, and in 1968, willed her home and 119 acres to the Maine Audubon Society, in what is now called the Josephine Newman Sanctuary. (GHS.)

The Georgetown Working League recently celebrated its 100th anniversary of supporting a wide range of community activities, including scholarships for local students. Here, a group of Working League women gathers on the steps of a summer cottage in the mid-20th century. (Elaine Todd Trench.)

In the 1890s, Boston photographer Fred Holland Day visited a friend, poet Louise Imogen Guiney, at her small cottage on Harmon's Harbor. Guiney had purchased a small fisherman's house, which Day referred to as "Castle Guiney." After Guiney moved to England in 1901, Day vacationed at her house, became enthralled with the area, and finally bought it from her in 1909. Soon thereafter, he moved it back from the water and built "the Chalet." (GR.)

Built in 1911, the Chalet was a summer residence for Fred Holland Day. Day invited underprivileged Boston-area children to spend summers exploring the woods and experimenting with photography. Early on, Day invited photographer Clarence H. White, his friend, to visit at Little Good Harbor. White bought a nearby old farmhouse, where his family spent many summers. The Chalet's current owners have beautifully restored it. (GHS.)

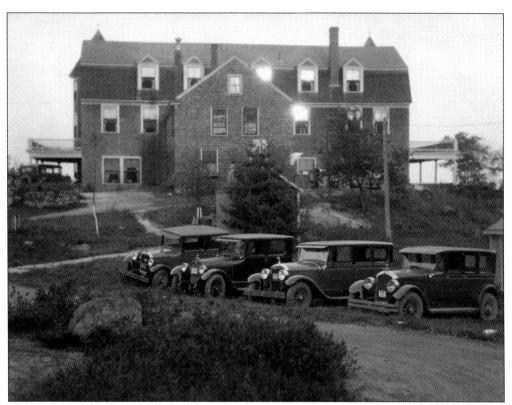

On the way to Reid State Park is the Grey Havens Inn, named the Seguinland Hotel when pictured here in 1927. During summers from 1910 to 1915, it was the site for the Clarence H. White Seguinland School of Photography. In an interview shortly before he died, White's son Clarence Jr. spoke of how his father and Fred Day would discuss how they might make a living out of this new art form—photography. (GHS.)

World-renowned photographer Paul Strand took this 1928 portrait of young Clarence H. White Jr. on the porch of the Seguinland Hotel. Strand was one of several artists, like Gertrude Kasebier and Max Weber, that Clarence H. White Sr. invited to be faculty members at his summer Seguinland School of Photography. Clarence Sr. died suddenly in 1925, and this photograph might represent a kind gesture by Strand to the youngest son of an old friend. (GHS.)

Gaston Lachaise and his wife, Isabel or "Madame," had a home at the corner of what are now Route 127 and Indian Point Road. It was Isabel who introduced Gaston to Georgetown. She and her first husband had vacationed here. Gaston was and is recognized as one of the finest sculptors from the 1920s and 1930s. Isabel was his muse and often his model. Today, his heroic works of voluptuous women can be seen worldwide. (Photograph by Paul Strand, *Gaston and Mme Lachaise, Georgetown, Maine,* c. 1928, courtesy of the Philadelphia Museum of Art, partial and promised gift of Marguerite and Gerry Lindfest.)

Here is the *Garden Lady,* one of Gaston Lachaise's familiar statues, when it stood by the Lachaise pool in Georgetown. When word got out that she was donated to the Portland Museum of Art, the local "Liar's Club" started a rumor that members were going to "kidnap" her and move her to a safe place. Maybe that is why the moving crew from Portland came at 3:00 a.m. (Lachaise Foundation.)

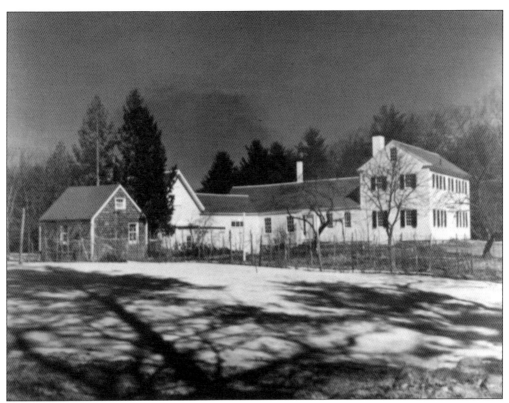

The James Riggs home in Robinhood has belonged to the Zorach family since 1923. Here, the view is over Marguerite Zorach's raspberry patch, with William Zorach's studio on the left near the barn. Their daughter Dahlov Ipcar still lives nearby in another Riggs home. Now in her nineties, she continues to paint and write, to the delight of a worldwide audience. (GR.)

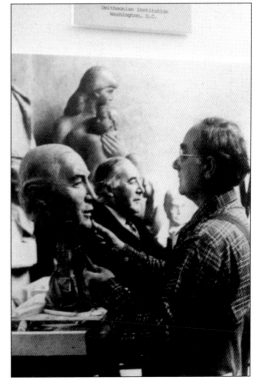

In this undated photograph, William Zorach works on a clay head, probably in his Brooklyn, New York, studio. His sculptures are in collections worldwide and in Maine at many museums. The *Spirit of the Dance* graces Robinhood Cove and *Spirit of the Sea* resides in the Bath City Park. Later, the John Marin family donated another sea spirit to the University of Maine at Machias. (GR.)

William Zorach is painting on the lawn in front of the old Harbor View Inn, later called the Five Islands Inn, in this photograph by Bill Tinkham. Zorach painted here quite often, using the garbage cans for an easel. Painting with watercolors was a source of relaxation from the heavy work of sculpturing. Note Malden Island in the upper-right corner. (GR.)

The beautiful statue *Spirit of the Dance*, or *Diana*, as she is known by friends and family, is on the Zorach home's shore overlooking Robinhood Cove. For years, the Boothbay tour boats came in to view her. She was a bronze copy of the aluminum one William Zorach made for Rockefeller Center in 1932. The author of this book helped Zorach build the stone base for *Diana*. (GR.)

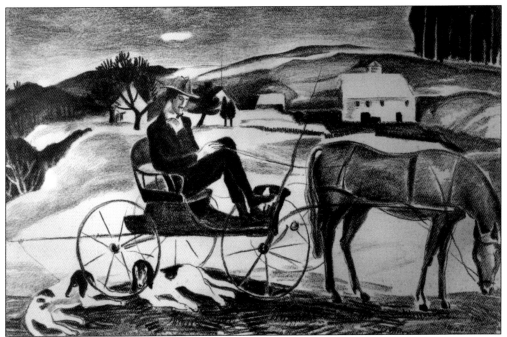

This c. 1930 Marguerite Zorach lithograph captures locally famous county deputy sheriff Ed Clarey in front of his farm in Robinhood. He got the nickname "Sink Spout Detective" from his habit of listening outside homes through the sink spout where dishwater was dumped. One night, a lady caught him in the act and dumped a pan of boiling hot water down the drain. (GR.)

This photograph of Ed Clarey shows him outside his farmhouse with his foxhound. Clarey earned his 15 minutes of fame on June 1, 1932, with a "rum bust" in the village of Marrtown on Georgetown Island. As a deputy sheriff, he and Deputy George Gray of Five Islands came upon an illegal liquor deal. Shots were fired, and the miscreants were arrested. (GR.)

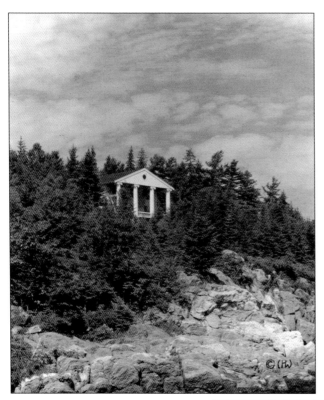

Around 1913, Fr. Waldo Hasenfus, a Boston-area Catholic priest and friend of photographer Fred Day, bought property on Harmon's Harbor from Walter Reid's Seguinland Reality Company. Hasenfus drew up the plans for Marycliff. Because of poor roads, he had the lumber and other items brought down from Massachusetts in the schooner *Annie M. Preble*, sailed by Captain Bunker. All was hauled up the steep cliffs with block and tackle. (GHS.)

This Bill Tinkham photograph shows the beautiful pillars of Marycliff, which came from Boston's Perkins Institute for the Blind. Local carpenters put it all together. Father Hasenfus ran a summer boys' camp for over 20 years, until 1938. Twelve former campers never returned while serving during World War II. For a few years after the war, the camp reopened. In 1994, an empty Marycliff fell to an arsonist's torch. (GR.)

Four

GEORGETOWN AT PLAY, LOCALS AND RUSTICATORS

Like the artists who came to the island, the rusticators came to Georgetown seeking a simpler life—at least for the summer. Most of them came from larger cities, where they were accustomed to modern conveniences like indoor plumbing, running hot and cold water, and electricity. However, the camps or summer homes they built were of many different styles and costs, thus some were simple while others were majestic.

In contrast to those who might come to Georgetown expecting an aloof and refined experience apart from the natives, these rusticators were more easily accepted into the community as equal, if not unusual, residents. They took to Georgetown with enthusiasm, engaging in outdoor activities such as fishing, clamming, boating, swimming, and hiking.

It did not take long for the residents of Georgetown to realize that they were sitting on a gold mine, and in the late 1800s and early 1900s, mostly along the water's edge, the people of the island built small camps to capitalize on this new source of revenue. Many fishermen suddenly became carpenters in the wintertime. The cottages were given colorful names like, Inchegela, Welikit, and Camp Bide-a-Wee.

The steamships and railroads also realized a growth in the number of passages booked from larger port cities to the south and west. In the early evening, a family traveling to Georgetown might board a steamship or train in Boston, New York, or Philadelphia, arriving in Bath the next morning. The final leg of the trip would be taken via smaller steamboat to local landings.

It was during this period that the many villages that are Georgetown took on a new and distinctly different flavor, with many visitors later choosing to become year-round residents.

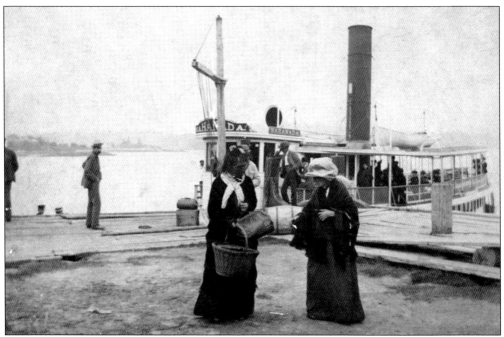

In the late 1880s, the Eastern Steamship Company steamer *Nahanada* has just unloaded two ladies at the Riggsville wharf. They had probably gone shopping in Bath. The boat is backing away from the pier and will head down to Five Islands. Many of the captains on these steamers were local men, including several from Georgetown Center, Five Islands, Boothbay, and Bath. (Clayton Heald.)

Langdon Oliver is the "Ancient Mariner" in this popular postcard, which can be found in collectors' shops around the country. Langdon owned a large farm on the Bay Point Road and enjoyed sitting on the wharf and talking with the rusticators who came in on the Eastern Steamship Line during their summertime vacations. Langdon had been a pilot for Kennebec River ships. Snappy down-east Maine comebacks were his specialty. (GR.)

Here, two women are enjoying the view of the village of Five Islands from the Otter Cliff Inn. The inn was built about 1890 by Marjorie Bailey of Woolwich. It was operated for many years as a summer hotel. On December 30, 1949, while under the ownership of Antonio Nicholas of Biddeford, it was destroyed by a chimney fire. Nicholas and his goats escaped unharmed. (GHS.)

The Harbor View Inn, later named the Five Islands Inn, looks out to Malden Island with the yellow cottage, which still stands today, in front. The inn served fine food and lodging for nearly 100 years and finished its days as a summer home for the Jones and Doolittle families. The Georgetown Fire Department burned it in a practice fire in 2004. (GR.)

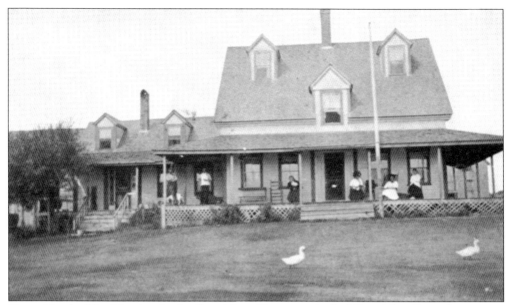

Owned by the Hinckley family, the Sagadahoc House overlooked Sagadahoc Bay, where it was run as a boardinghouse for summer folks for several years. With a great view down the wide bay and out to the ocean, it is no wonder it was popular. Having a goose on the lawn was no doubt additional entertainment for these folks on the porch. Descendants of the Hinckley family live there still. (GHS.)

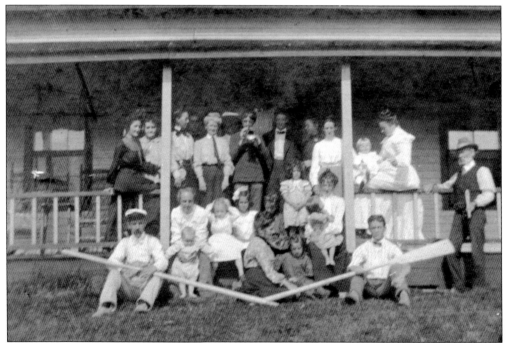

In 1900, Abbie Reynolds's Boardinghouse on Robinhood Cove was a summer vacation home for her Boston tourists, whom she found with ads in the *Boston Globe*. The horse-drawn carriage, also known as the "Riggsville Taxi," was her guests' transportation. Posing on the front porch are some 20 guests. Her husband, Eugene, is on the right. (GR.)

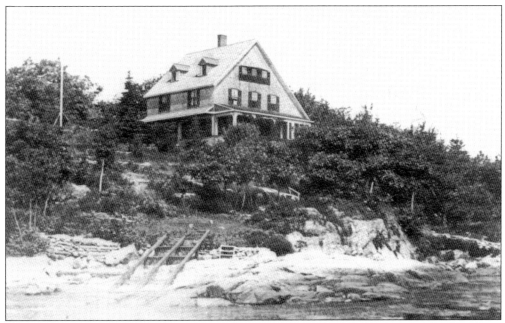

Rockmere Lodge was a very popular bed-and-breakfast on the Five Islands shore overlooking Crow Island. In 1902, the Wade family built the first namesake cottage, and their niece Helen Horton built a large three-story cottage nearby. After the disastrous Five Islands fire of 1934, they sold to Harriet Worrell, who had Clint McFadden of Bath build her the present lodge in 1937. (GR.)

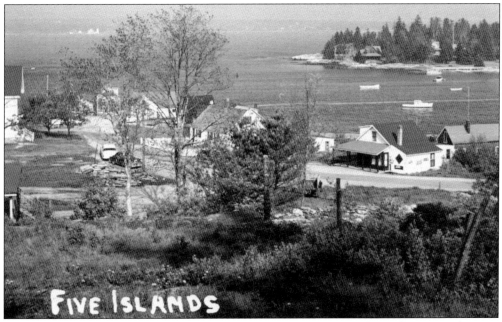

A 1960 Five Islands photograph shows the Five Islands Ice Cream Parlor, right center; the store and wharf, top left; and Malden Island, top right. This scene was the subject of a William Zorach watercolor that Elizabeth Noyes purchased and donated to the Portland Museum of Art. (GR.)

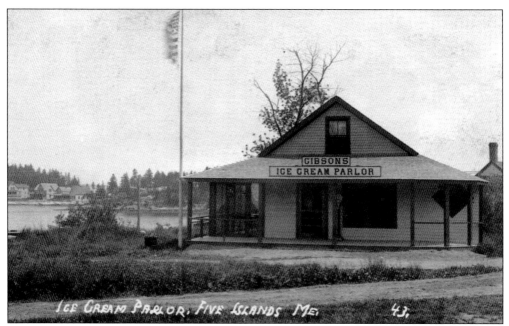

The Five Islands Ice Cream Parlor was a gathering place and hangout for many generations of teenagers, as well as adults. Built in the early 1900s by the Rowe family, it was the center for refreshments and friendships for many from all around Georgetown Island. (GR.)

This building in Georgetown Center once sat by the west end of the east bridge when it was built for the Berry Shipyard. As the photograph shows, it was once the Georgetown Center Ice Cream Parlor. It was later moved across the street and a little to the west, where it now serves as the Freebergs' garage. (GHS.)

The very entertaining Georgetown band of 1888 is comprised of, from left to right, Chris Marr, Gus Jordan, Will Berry, Herb Spinney, Pres Stedman, Howard Heald, Len Trafton, John Brown, Will Berry, Will Todd, Herb Oliver, Gene Trafton, Charles Smith, Howard Trafton, John Williams, and Everett Higgins. (David Trafton.)

Here is the final game of the Five Islands' version of the World Series. (In 1948, the Boston Braves were the National League Champs.) It was a Labor Day doubleheader between Rev. Waldo Hasenfus's team of Boston boys and the Five Islands' nine. The locals swept the doubleheader, winning the series four games to three. Cleon Pinkham started all seven games. Note the ice cream parlor in center field. (GR.)

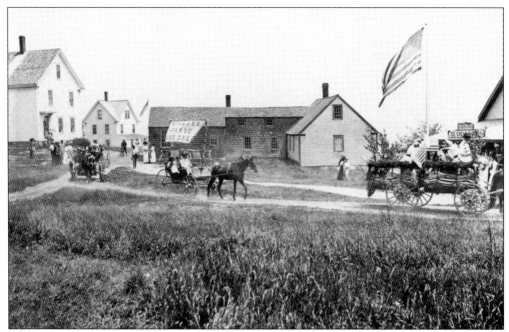

This late-1880s Fourth of July parade traveled around the square and ended up at the Five Islands Ice Cream Parlor, across from the ball field. After a few years' gap, this tradition has been renewed. Georgetown's young and old, year-round and seasonal, participate in the parade, and some even make creative floats. This and the Blessing of the Fleet are two of the many popular summer events on the island. (Peter Bacon.)

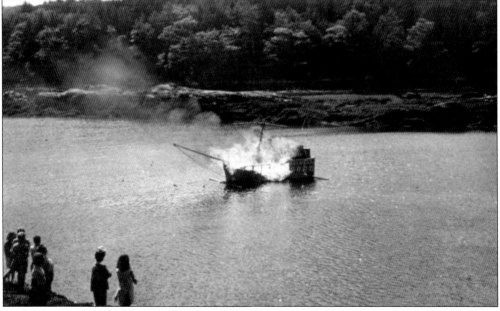

Evidently, pirate raids did not end in the 17th century. During a 1965 Fourth of July celebration on Bruk's field on Oak Road it happened again. Rick Hasenfus built the pirate ship on a ledge out of cardboard and strapping; Roy Clark and Rick Reynolds, in a canoe, attacked the ship with flaming arrows, and it burned to the water's edge. (GR.)

Agnes Snyder Jones Powers, Riggsville schoolteacher, postmistress, Methodist minister, and local historian, is shown around 1920 with her prized racehorse, Prince Bayard, outside the Riggsville Grammar School. Farther behind Powers is the Robinhood Free Meetinghouse. Powers married one of her students, Cal Powers of Robinhood, which was not an unusual occurrence at the time in some towns. (GR.)

For years, the Georgetown Liars Club held its meetings in Todd's Store. Members earned much fame—well, they did get their photograph in the *Portland Press Herald*, once. Note the badges they wear, for lying, awarded to them by Prof. Charles Shain of Indian Point. They are, from left to right, Harry Horne, Everett Stevens, Ralph Davis, Will Todd, and Alton Reed. (GHS.)

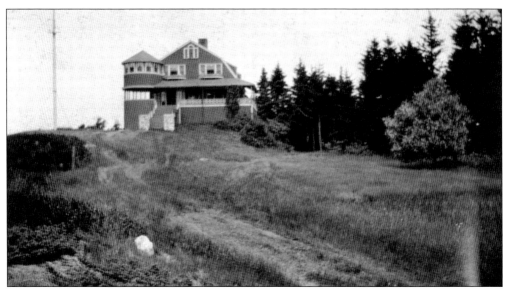

Martha Rich Bowen established Camp Overlook in 1923. It was located on a high knoll on Kennebec Point, just above the old cemetery. Unlike most camps, where tents were used, Martha had several bungalows built along Sagadahoc Bay. It closed in 1938 and is now the residence of one of her descendants. (GR.)

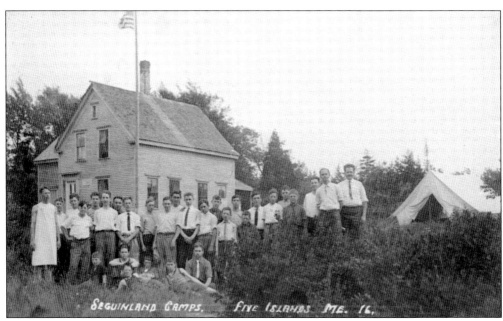

Another Walter Reid venture was the Seguinland Boys Camp, one of a dozen boys' and girls' camps that operated during the 1920s and 1930s in Georgetown. This one shows a group of young men near Little Good Harbor. They slept in tents and had their meals served in an old farmhouse. There was plenty of action, with swimming and boating on nearby Harmon's Harbor. (GHS.)

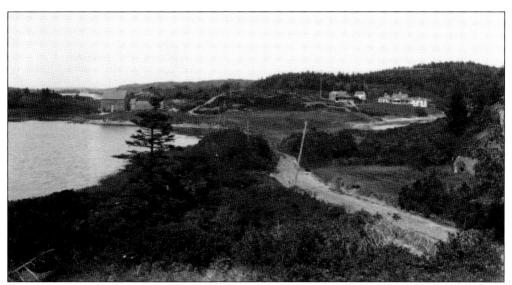

The town road to Kennebec Point has changed a bit since this picture was taken. The body of water named Heal's Eddy is on the left, and the home of early settler George Todd can be seen in left-center. The old cemetery is in the lower right; it contains some unmarked fieldstones for early settlers' graves and some more recent. (GHS.)

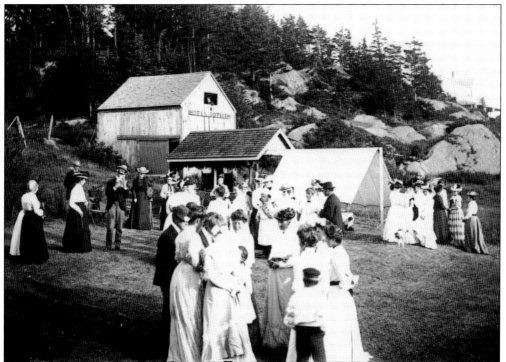

The Anchorage on Kennebec Point has been the summer home of the Carlisle family since Edward and Ida Carlisle hired Benjamin Hinckley of West Georgetown to build it in 1898. It was the fifth summer cottage to be built on the point and guests were housed in the barn, seen here, nearer the beach, which was called Hotel Do-Tell-Em. The barn is now a separate private residence. (GR.)

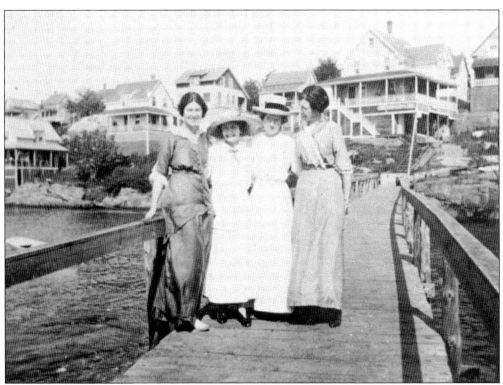

Standing on Spinney's wharf are the four Howard sisters, summering on Bay Point by way of Brooklyn, New York. In random order they are Bess Adams; Millie Keene; Louise Howard, who was a World War I nurse; and Ruth Detrick. (GHS.)

This small building on the water at Bay Point was, as the sign says, Aunt Lou's Gift Shop. Aunt Lou (Louise Howard) was a well-known resident in this Georgetown village. A prolific writer and local historian, she wrote a weekly column for the *Bath Independent* for over 40 years. (GHS.)

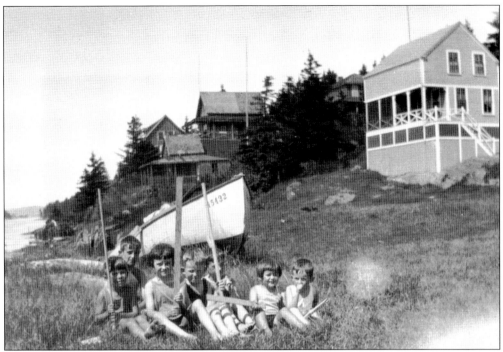

Several children are gathered at the Conley cottage on Bay Point. Jack Swift, front left, and his sister Kate Swift, second from right, are visiting with the Conley children. In the late 1880s, Jack's grandparents J. Otis and Daisy Peabody Swift first introduced the family to the area. Jack, along with Hal Bonner and Gene Reynolds, the self-described "Three Old Men," were instrumental in establishing a permanent home for the local historical society. (GHS.)

The following is from *Bath Independent* newspaper on July 3, 1909: "Work upon the new casino is underway and in charge is William Delano of Five Islands. The building will measure 35 feet by 64 feet and will be something which all Bay Pointers will enjoy." The casino, shown in this 1937 photograph, was used as a dance hall and community meeting place. (GHS.)

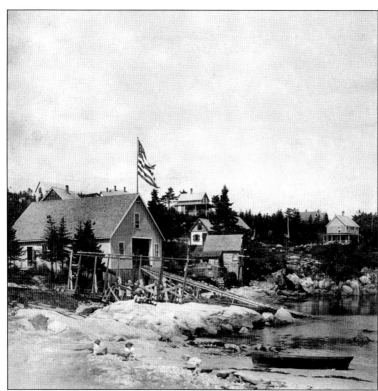

This Ledgemere boathouse still stands near what is now a public beach access at the entrance to Ledgemere Road. For many years, Warner Eustis used it to store his sailboat and motorboat, both having been tended by local veteran sailor Tom Watson. Eustis donated the property's many acres of spruce forest and the home at the end of the road to the Nature Conservancy. Both the home and the boathouse were sold. (GR.)

There was a time when Malden Island cottage owners ran the cookhouse on Malden, and they often hired locals to cook and wait tables. Posing on the Malden Island Wharf in this c. 1930 group are, from left to right, (first row) Alice Pinkham MacGillivary, Iva Cromwell, and Edith Marr; (second row) Chris Pinkham Stevens, Aurelia Gray Pinkham, and three unidentified workers. (GHS.)

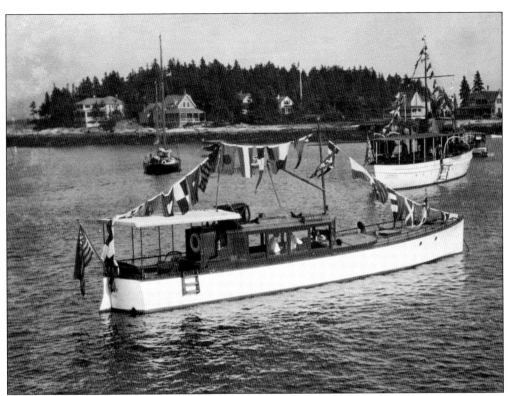

Several of the Malden Island families belonged to the Boston Yacht Club. During the early 1900s, Boston-area sailors often took long trips down east and, in the course of these voyages, would generally stop at Five Islands and join the folks on Malden Island for a lobster feed. (GHS.)

This view of the Reverend Boynton's Friendship sloop *Sky Pilot* at her mooring in Five Islands Harbor off Malden Island shows her with her bow pointing northeast toward Crow Island and drawing attention to her main deck and broad beam. (GR.)

In this 1988 photograph, Marjorie Hinckley Higgins is digging a few clams on her front lawn—well, almost. The Sagadahoc Bay mudflats are among the greatest areas for digging clams along the coast, and Marge lived just a quahog's throw away. Today's clam diggers still find it so. Local and state authorities manage the valuable natural resource by requiring commercial and recreational licenses obtained from the town. (GHS.)

REPTILE ROCK GEORGETOWN, MAINE

Crouching about a half mile on the left after one crosses the Arrowsic-Georgetown Bridge, Reptile Rock, or Lizard Rock, has become a Route 127 landmark upon entering Georgetown. The Reynolds siblings applied the first coat of green paint in the mid-1960s. Uncle Keith Reynolds supplied the surplus paint, and they went to work. Depending on the holiday, suitable attire might be added. (Drawing by Mary Leonard, GR.)

This view of Reid State Park's Mile Beach clearly shows why it is popular with beach and nature lovers. It is hard to image that during World War II American and Allied air forces used it for target practice. Look down the sands toward Todd's Point where the targets floated and try to visualize planes roaring out of the western sky, firing machine guns and dropping practice bombs. Luckily, Reid Park survived just fine. (GR.)

The rocky shore and beautiful beaches of Reid State Park were a grand gift by local boy and successful businessman Walter Reid. Many artists as well as beach enthusiasts find it inspiring. Artist Claude Montgomery is shown here painting around 1971. Nationally known as a fine portrait artist, he had a summer home just a short walk from the beach. Pres. John Kennedy was one of his famous subjects. (GR.)

The East Beach picnic tables over near the first parking lot and the park shelter are empty, indicating summer is over. Off-season is still a popular time for many visitors, especially locals, to go to the park for a walk or jog, watch the surf, or just enjoy the views of the islands and the Atlantic Ocean. Griffith Head is in the background. (GR.)

In 1983, some local youths took exception to graffiti on a rock outcropping near Reid State Park. Their solution was to covertly paint it, since no permission was obtained, with an American flag. Thirty years later, the flag was still there but looking shabby. This 2013 picture includes some of the original artists and other volunteers: from left to right, Todd Barabe, Ralph Wilkinson, Samantha (Moulton) Wilkinson, Jason Barabe, John Thibodeau, and Steve Thibodeau Jr. in front of the revitalized work. Not pictured is Allen Goodrich. (GHS.)

118

Five

PRESERVING ITS HISTORY

John Donne (1572–1631) wrote, "No man is an island, entire of itself; every man is a piece of the continent, a part of the main."

It is not that prior to 1975 no one in Georgetown had thought about preserving history. In fact, individuals and families had been doing so for generations, in diaries, family Bibles, letters, and in oral histories. Places of worship, schools, Granges, and town halls kept records of births, deaths, marriages, students, agricultural organizations, land holdings, and other property inventories for hundreds of years. But in 1975, perhaps with the additional incentive of preparing for the nation's bicentennial, an enthusiastic group incorporated the Georgetown Historical Society (GHS). Those same folks, with the support of many others, went to work raising funds and restoring the old South School or, as most in Georgetown know it, the old stone schoolhouse on Bay Point Road. The school was added to the National Register of Historic Places and became the physical center for the GHS organization.

As with other coastal towns, Georgetown felt the change toward a more mobile society. Visitors became seasonal residents, and others looking to live here were no longer dissuaded by a commute of 30, 40, or even 50 miles. Children became increasingly likely to leave town, for school or work, and opt not to return, except for visits.

In such times, how can a community respond to such ebb and flow and still keep the dots connected, the threads intertwined, and the generational history preserved? For some, the answer came with building a home for the Georgetown Historical Society—a permanent repository for the artifacts, papers, photographs, maps, and genealogical information that show how Georgetown became what it is. However, it also requires that each person place a value on preserving the pieces—literally the pieces—of the island's history. Otherwise, when today is gone, who will tell the stories? How will the generations that follow know what it was to be here, now? After all, no man, or woman, or child is an island, entire of itself.

The Georgetown Historical Society was established in 1975; however, its first permanent home, the GHS Center for History and Culture, opened on Bay Point Road in June 2007, after seven years of planning and fundraising. The result is a safe archival repository and research library about island history. It is open year-round. (GHS.)

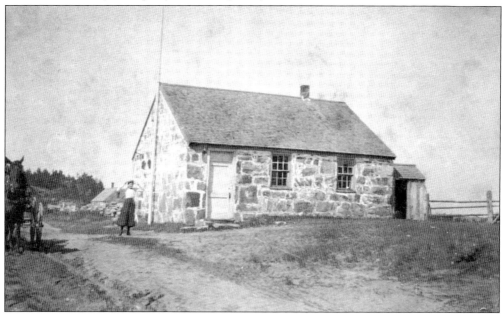

Here is a c. 1900 image of the 1820 Bay Point stone school, also called the South School and the Down Island School, presumably built by Irish stonemasons. The last class was here in 1910. To prevent students from being distracted by passing wagons, there are no windows along the road. During summers from 1975 to 2003, GHS used the school for displays and welcomed visitors two afternoons a week. (GHS.)

Donated items are the core of the GHS archival collection. Maps, such as this 1858 map of Sagadahoc County donated by sisters Sally Jones and Jane Kennedy, are part of a growing collection. Former GHS president Lynne Anderson Jones accepted this gift when the society was at its temporary headquarters (2003–2007) in the former Georgetown Center Post Office. (GHS.)

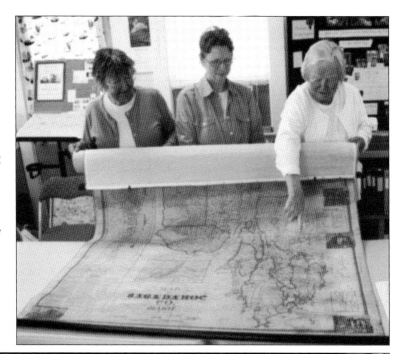

Sometimes, it takes more than a village. Here are a few members of the NMCB 27 (US Navy Seabees) during the construction of the GHS building in the summer of 2006. After a very competitive application process, this became one of 11 projects nationwide honored to be a training site for the Navy construction unit. Representing GHS, not in uniform and from left to right, are Jack Swift, Bill Herman, Bob Trabona, construction manager Chuck Frohmiller, Lynne Jones, Jeanne Bailey McGowan, and Gene Reynolds. (GHS.)

Marjorie Hinckley Higgins made this teddy bear named Mr. Sagadahoc from a worn, but treasured, family coverlet. Wool for the blue-and-white coverlet came from Mary Sylvester Tobey's family sheep farm. Tobey, who spun the wool and made the coverlet, was Marge's great-great-grandmother. Marge donated this treasured family article to GHS in 2004. (GHS.)

Marguerite Zorach's 1928 painting of Guy Lowe, titled *Guy Lowe, the Last Lowe of Lowe's Point,* is an evocative portrait of a Georgetown native. This large oil-on-canvas work was recently donated to the Georgetown Historical Society. Guy will now remain in his hometown forever. (GHS.)

Community programs often focus on local history, but it is also important to capture current events and cultural interests to document Georgetown today for future generations. At this GHS book signing, artist and author Dahlov Ipcar signs one of her books for Sarah Watson Kulis and her daughters, Dory and Brook. (GHS.)

Most community-based nonprofits rely on the talents of volunteers. One outstanding volunteer who gave decades of her life to preserving Georgetown history was Carolyn F. "Billie" Todd. Among numerous other things, she served as editor of the society's bimonthly publication, the *Georgetown Tide*, for many, many years. One of her greatest contributions to Georgetown was the donation of Higgins Mountain to be preserved forever for public use. (GHS.)

As he has for many in Georgetown, Eugene A. "Gene" Reynolds continues to be a preeminent source of local historical and genealogical information. Reynolds's family roots "go deep" here, as do those of his wife's family. He and Claire MacGillivary Reynolds are pictured here at the opening of the new GHS Center in 2007. (GHS.)

This 1936 image shows Eugene Reynolds and his sister Doris at the Reynolds farm on Route 127 in Georgetown. The family still owns the property. Truly, the Reynolds family has had a profound impact on the preservation of the community's history and culture. (GHS.)

BIBLIOGRAPHY

Bischof, Libby, and Susan Danly. *Maine Moderns: Art in Seguinland, 1900–1940.* New Haven, CT: Yale University Press, 2011.

Chandler, E.J. *Ancient Sagadahoc: A Story of the Englishmen Who Welcomed the Pilgrims to the New World.* Self-published, 1998.

Etnier, Elizabeth. *On Gilbert's Head: Maine Days.* Boston: Little, Brown and Company, 1937.

Georgetown Historical Society. *Georgetown Goes Modern: The Modern Art Movement Meets an Island Community.* Georgetown, ME: Georgetown Historical Society, 2012.

Gilman, Stanwood C., and Margaret C. Stanwood. *Georgetown on Arrowsic: The Ancient Dominions of Maine on the Kennebec 1716–1966: 250 Anniversary Celebration.* Self-published, 1966.

Gunnell, Frances "Babe." *A Nice Life Back Then: Georgetown Island 1900–1920.* 2nd ed. Georgetown, ME: Georgetown Historical Society, 2011.

Hanna, Thomas. *Shoutin' into the Fog: Growing Up on Maine's Ragged Edge.* Yarmouth, ME: Islandport Press, 2006.

Hasenfus, Nathaniel J. *We Summer in Maine.* West Roxbury, MA: Sagadahoc Publishing, 1946.

Little, Carl. *The Art of Dahlov Ipcar.* Camden, ME: Down East, 2010.

Lyons, Joyce Sprague. *Marrtown: Deserted Village to Revival, Georgetown Island, Maine.* Georgetown, ME: Georgetown Historical Society, 2000.

McLane, Charles B. *Islands of the Mid-Maine Coast: Pemaquid Point to the Kennebec River.* Vol. 4. Gardiner, ME: Tilbury House, 1994.

Morgan, Patricia. *A Glimpse into the Past of Five Islands, Maine.* Self-published, 1999.

Oaks, Martha. *Preserving an Inheritance: The Historic Significance of Two Buildings at Five Islands.* Georgetown, ME: Georgetown Town-Owned Property Management Board, 1982.

Shain, Charles, and Samuella Shain, eds. *The Maine Reader: The Down East Experience, 1614 to the Present.* Boston: Houghton Mifflin Company, 1991.

Todd, Carolyn F. "Billie." "Georgetown, A Brief Historical Perspective." *Georgetown Tide,* 1975.

Webster, Sereno Sewell, Jr. *A History of Indian Point.* Self-published, 2007.

Woodard, Colin. *The Lobster Coast: Rebels, Rusticators, and the Struggle for a Forgotten Frontier.* New York: Viking Penguin, 2004.

Zorach, William. *Art is My Life: The Autobiography of William Zorach.* Cleveland: World Publishing Company, 1967.

About the Organization

The mission of the Georgetown Historical Society (GHS), founded in 1975, is to explore, preserve, and celebrate the history and cultural landscape of the town of Georgetown, Maine. The GHS is "Actively Connecting Generations Through Georgetown History," and the research library and archival collections of the GHS are valuable resources for the history and culture of Georgetown and its immediate environs. The growing collection of documents, books, maps, photographs, and artifacts is housed at the GHS Center for History and Culture, which is open year-round, Wednesdays, 10:00 a.m.–5:00 p.m., and Saturdays, 10:00 a.m.–12:00 p.m. Educational and community programs are held at the center. The GHS can be contacted as follows:

Georgetown Historical Society
20 Bay Point Road, P.O. Box 441
Georgetown, Maine 04548
207.371.9200
georgetownhistorical@gmail.com
www.georgetownhistoricalsociety.org
also on Facebook

DISCOVER THOUSANDS OF LOCAL HISTORY BOOKS
FEATURING MILLIONS OF VINTAGE IMAGES

Arcadia Publishing, the leading local history publisher in the United States, is committed to making history accessible and meaningful through publishing books that celebrate and preserve the heritage of America's people and places.

Find more books like this at
www.arcadiapublishing.com

Search for your hometown history, your old stomping grounds, and even your favorite sports team.

Consistent with our mission to preserve history on a local level, this book was printed in South Carolina on American-made paper and manufactured entirely in the United States. Products carrying the accredited Forest Stewardship Council (FSC) label are printed on 100 percent FSC-certified paper.